Humanities Handbook

Humanities Handbook

Bruce S. Thornton

 Prentice Hall Upper Saddle River, New Jersey 07458

Library of Congress Cataloging-in-Publication Data
Thornton, Bruce S.
 Humanities handbook / Bruce S. Thornton.—1st ed.
 p.cm.
 ISBN 0–13–016664-2 (pbk.)
 1. Humanities—Handbooks, manuals, etc. 2. Learning and scholarship—Handbooks,
manuals, etc. I. Title.
AS5 .T48 2000
001.3—dc21

 00-044077

Editorial Director: Charlyce Jones Owen
Acquisitions Editor: Bud Therien
Assistant Editor: Kimberly Chastain
Director of Production and Manufacturing: Barbara Kittle
Production Editor: Louise Rothman
Editoral Assistant: Wendy Yurash
Prepress and Manufacturing Manager: Nick Sklitsis
Prepress and Manufacturing Buyer: Sherry Lewis
Marketing Director: Beth Gillett Mejia
Marketing Manager: Sheryl Adams
Cover Design: Bruce Kenselaar
Manager, Production/Formatting and Art: Guy Ruggiero

For permission to use copyrighted material, grateful acknowledgment is made
to the copyright holders listed on page 152, which is considered an extension
of this copyright page.

This book was set 11/13 Cremona by Carlisle Communications, Ltd. and printed
and bound by Courier Westford
The cover was printed by Phoenix Color Corp.

 © 2001 by Prentice-Hall Inc.
Prentice Hall A Pearson Education Company
 Upper Saddle River, New Jersey 07458

Printed in the United States of America
10 9 8 7 6 5 4 3 2 1

0-13-016664-2

Prentice-Hall International (UK) Limited, *London*
Prentice-Hall of Australia Pty. Limited, *Sydney*
Prentice-Hall Canada Inc., *Toronto*
Prentice-Hall Hispanoamerica, S.A., *Mexico*
Prentice-Hall of India Private Limited, *New Delhi*
Prentice-Hall of Japan, Inc. *Toyko*
Pearson Education Asia Pte. Ltd., *Singapore*
Editora Prentice-Hall do Brasil, Ltda., *Rio de Janeiro*

Contents

Acknowledgments

I would like to thank the following reviewers for their helpful comments and suggestions: Peter Scheckner, Ramapo College; Charles Carroll, Lake City Community College; Cortlandt Bellavance, Atlantic Cape Community College; and Michael P. Berberich, Galveston College.

Preface

Every human endeavor depends on commonly shared terms, concepts, and categories that make the task easier and more efficient. Studying and talking about the humanities—the great works of art, literature, history, philosophy, and music of the Western tradition—are no different. Part of becoming educated in the humanities is mastering these terms and concepts that are taken for granted by teachers and experts, so that specific works can be discussed and analyzed without constant redefinition of basic terms and ideas.

This handbook attempts to provide students with the most basic and general definitions of the terms and ideas that are likely to come up in introductory humanities, literature, and Western civilization courses. The words in boldface type in the text are also entries in the handbook. This book gives students a basic awareness of important terms and concepts that will facilitate other reading and save time and frustration. As such, the terms chosen are the ones that in my twenty years of teaching such courses typically stump students. Thus, the criteria of selection and emphasis obviously are to some degree subjective, and I apologize for any important terms I have omitted.

My hope is that the students' experience with their other class texts, whether primary or secondary, and with their instructor's lectures and other class materials will be enhanced by having at hand a guide to the terms that are likely to be used when those materials are presented. These definitions, moreover, are intended to be general: They are only the first step for the student in furthering his or her understanding of these key ideas and terms. It is hoped that as class progresses and the student reads primary works and listens to lectures and analyses of ideas and themes, these general definitions will be fleshed out and elaborated.

ABSOLUTISM, absolutist, absolute In **ethics,** absolutism is the belief that some actions are always right or always wrong. For example, believing that there are no circumstances in which it is permissible to kill a human being would be an absolutist position. See **consequentialism.** Also a political theory that arose in the seventeenth century, absolutism puts complete power over all aspects of social, political, and economic life in the hands of one person, particularly a king, who will then be able to eliminate destructive factions within a state and create order and unity. Thomas Hobbes's *Leviathan* (1651) is an important statement of political absolutism; France's Louis XIV (1638–1715) who said, "I *am* the state," realized this ideal most completely. See **ethics, tyranny.**

ABSTRACT, abstraction An **idea** or term that exists only mentally, apart from specific instances. See **concrete.**

ABSTRACT ART, abstract expressionism Is not concerned with accurate **representation** of people or things or with **realism** but focuses more on **form,** shape, and color within the context of the act and the materials of painting itself: For example, **perspective** may be ignored because it creates the illusion of three-dimensional space, whereas the canvas itself is flat. Abstract expressionism is a type of abstract art that first appeared after **World War II.** It added to abstract art's focus on form, the artist's personal emotional intensity and expression, and a concern with the **subjective** response to shape and color. Perhaps the most famous American abstract expressionist is Jackson Pollock (1912–1956), who took abstraction to the extreme of flinging, dripping, or spattering paint onto the canvas. This kind of

painting also was known as action painting to emphasize the engagement of the artist, both physically and emotionally, in the act of applying the paint to the canvas. See **modern art.**

ABSURD, the absurd, absurdist A term describing a world perceived as meaningless in human terms because people are isolated in an alien, inhuman universe once filled with the presence and certainty of God and his **providential** love and order. Hence, everything we do or suffer happens against the backdrop of an indifferent natural world and its amoral, blind forces. The Greek myth of Sisyphus, who is condemned for all eternity repeatedly to push a huge rock up a hill only to have it roll back down, can be used to describe the absurdist view, as Albert Camus does in his book *The Myth of Sisyphus and Other Essays* (1942). In literature, theater (the "theater of the absurd") has expressed this vision the best. In this sort of drama, confused characters undergo strange, even fantastic, disconnected, and disconcerting experiences that lead nowhere and ultimately mean nothing. Samuel Beckett's *Waiting for Godot* (1953) is probably the best-known example. See also **existentialism.**

ACADEMY, the A name for the **Platonic** school of **philosophy,** after its location in Athens near a shrine to the hero Academus. Now sometimes used to designate the university.

A CAPELLA Music sung without instruments.

ACHILLES In Homer's *Iliad* (c. 700 B.C.), the best fighter of the Greeks and highest embodiment of the **epic hero.**

ACOUSTICS The qualities of a room or building that have to do with how clearly sounds can be heard or transmitted in it. Also, the science of sound.

ACROPOLIS The citadel of an ancient Greek city, on a hill or mountain. The famous Acropolis is the hill with its fifth-century B.C. ruins in Athens.

ACT The principal division of a **drama.**

ACTIUM, Battle of The sea battle in which Octavian (later Augustus) defeated the forces of Mark Antony and Cleopatra (31 B.C.). Octavian's victory gave him supremacy in Rome, leading four years later to the creation of the **Roman Empire.**

ADAGIO A direction indicating that a musical piece should be played slowly.

AD HOMINEM A logical **fallacy** that results when someone attacks the person rather than the soundness of the argument.

AENEAS Trojan warrior in Homer's *Iliad* and the hero of the *Aeneid* (19 B.C.) of the Roman poet Vergil (70–19 B.C.), who makes him the founder of Rome.

AESTHETIC, aestheticism, aesthetics, aesthete, aesthetic distance Aesthetic refers to our appreciation, critical awareness, and understanding of beauty and taste in art, music, and literature, usually apart from any utilitarian value art may have, or any connection to reality: Beautiful things are valuable simply because they are beautiful, not because they are useful socially, politically, or morally, and they should be judged on their own terms. Aestheticism was a movement predominantly of the late nineteenth century in which these assumptions about the independent value of art—even its superiority to reality—were affirmed and celebrated: "Art for art's sake" is aestheticism's credo, and Oscar Wilde its most well-known proponent. Aesthetics is the "science" of beauty, focusing both on how we define art and beauty, and on why we enjoy beauty. An aesthete is a person dedicated to the pursuit and appreciation of artistic beauty at the expense of any other values such as morality or utility. Aesthetic distance refers to the suspension of emotional response in order to appreciate and understand a work of art. Aestheticism in the twenty-first century is out of favor, as much contemporary criticism is more concerned with **historicist** or

political interpretations of art and literature. Hence, aestheticism is seen as overly **subjective,** elitist, and irresponsible for ignoring the greater issues of social justice and the distribution of power and privilege that some critical schools believe is the definitive context of art and literature.

AGINCOURT, Battle of Battle fought October 25, 1415 between the French and the English under Henry V (1387–1422). The battle was significant for the key role the English archers played in the victory over the French knights. See **Hundred Years War.**

ALCHEMY, alchemical A **medieval** pseudoscience whose aim was to turn base metal into gold.

ALEXANDRIAN From Alexandria, a city in northern Egypt founded by Alexander the Great (356–323 B.C.). It was famous for its Library (founded by Ptolemy Philadelphus in the early third century B.C.), which was actually a research center and museum as well as a collection of books. As an adjective, *Alexandrian* suggests artificiality and purposeful obscurity.

ALEXANDRINE A twelve-syllable line common in French poetry. Occasionally used in English, as in eighteenth-century English poet Alexander Pope's line defining the alexandrine: "That like/ a woun/ded snake/ drags its/ slow length/ along." See **meter.**

ALLAH The supreme God of **Islam.**

ALLEGORY, allegorical A story or painting with two (or sometimes more) meanings: one surface meaning obvious from the **plot, characters,** and **images,** and another meaning that the plot, character, and images represent. Often the first layer is simple and **concrete,** whereas the second is more complex and **abstract.** Thus, in allegory a person, object, or animal can represent an idea, **virtue,** or quality, as in the fifteenth-century morality

play *The Summoning of Everyman,* in which appear characters named Strength and Good Deeds. The parables in the New Testament are examples of simple allegories, as are Aesop's fables. Allegory is a way of using concrete, vivid images, characters, and events to talk about abstract ideas, whether moral, religious, philosophical, or political.

ALLEGRO A direction indicating that a musical piece should be played fast.

ALLUSION, allusive A reference in literature and art to a historical, philosophical, literary, or religious person, event, or object. Sometimes the reference is explicit and obvious, sometimes it is more subtle and even obscure. Allusion depends on a body of knowledge shared by artist and audience. In English literature, for example, references to the King James Bible and to ancient Greek and Latin literature and history are frequent because most people were familiar with the Bible and the **classics.** For example, when Simon Daedalus in James Joyce's *Ulysses* (1922), itself an extended allusion to Homer's *Odyssey* (c. 700 B.C.), ironically calls his son Stephen's friend Buck Mulligan his *fidus Achates,* "faithful Achates," he is alluding to Vergil's *Aeneid* (19 B.C.), in which the main character **Aeneas's** most trustworthy companion Achates is repeatedly called *fidus Achates.* This is an example of an allusion that was obvious at the time when Joyce wrote but today is probably considered obscure.

ALTARPIECE Paintings or sculptures that decorate the space behind or above an altar. An altarpiece with three panels is called a triptych; one with more than three panels is called a polyptych.

ALTO The lowest female voice (also called contralto) or boy's voice.

AMAZONS Mythical race of warrior women who lived without men and frequently are defeated in battle by Greek heroes.

AMBIGUITY A conscious artistic effect that creates an uncertainty of meaning or that suggests several possibilities of interpretation, not any one of which is the "correct" one. In the best art ambiguity is purposely used to communicate the richness and complexity of language, art, and life, all of which often have simultaneous multiple rather than single meanings or significance.

AMBULATORY The aisles of a church on either side of the **apse** and often containing **chapels.** See Figure 1.

ANALOGY, analogous An analogy is a comparison between things which share some characteristics, with the suggestion that because of these similarities there are likely to be others. Analogy is especially useful when trying to grasp something hard to understand, such as God. When the similarities are merely superficial or are overwhelmed by the greater number of differences, the analogy is "false."

ANAPEST, anapestic See **meter.**

ANARCHISM, anarchist The political belief, influential in the late nineteenth and early twentieth centuries, that holds all forms of government to be illegitimate coercion; thus, people should organize themselves socially on the basis of voluntary cooperation and agreement among free individuals without any compulsion.

ANCIEN RÉGIME Specifically, the term for the **monarchical** and aristocratic government in France in the seventeenth and eighteenth centuries before the French Revolution. Sometimes used generally of all European aristocratic government and **culture.**

ANDANTE A direction indicating that a musical piece should be played "at a walking pace."

ANGLICAN Adjective referring to the Church of England or its doctrines, created by Henry VIII (1491–1547) in the sixteenth century. See **Reformation, Protestantism.**

ANNUNCIATION The angel Gabriel's announcement to Mary, mother of Jesus, that she is pregnant with the Messiah and Redeemer. A frequent subject in **medieval** and **Renaissance** art.

ANTHROPOMORPHISM, anthropomorphic, anthropomorphize Giving human qualities, emotions, or physical characteristics to animals or objects. When you say your cat "loves" you, you are anthropomorphizing. The ancient Greek gods, who have human bodies and emotions, are good examples of anthropomorphism.

ANTIHERO A literary character who lacks the qualities of the traditional hero. The traditional hero is brave, trustworthy, noble, and good, whereas the antihero is fearful, mean, dishonest, or cynical and sometimes even evil. The popular hero succeeds, the antihero fails at some level. The antihero flourishes in a world devoid of meaning and value and, hence, inimical to the traditional heroic virtues, which are now **absurd** or naive. Most heroes of modern literature and popular culture are antiheroes. Philip Roth's Micky Sabbath from *Sabbath's Theater* (1997) is a good example. See **hero.**

ANTIQUITY The ancient world, especially Greece and Rome, until the sixth century A.D. See **classical.**

ANTI-SEMITISM, anti-Semitic A hatred of and belief in the inferiority of Jews, along with the acceptance of discrimination against them.

APARTHEID In South Africa the strict legal, social, and cultural segregation of whites from blacks, Indians, and mixed-race peoples, now formally dismantled. Used **metaphorically** for any sort of racial segregation, even informal.

APHRODITE Greek goddess of sex and sexual beauty, associated with the Greek islands of Cyprus and Cythera.

APOCALYPSE, apocalyptic In some Christian and Jewish writings, the "end of time" when God destroys the wicked and gathers to himself the righteous. Sometimes used figuratively of anything concerned with the ultimate, cataclysmic destiny of the world.

APOLLO Greek god of **reason,** poetry, the lyre, healing, and prophecy. Also associated with the sun. His oracle at Delphi was consulted in ancient Greece for information regarding the future. He is associated as well with the island of Delos, where he was born. Sometimes called Pythian after the snake he slew, called Python.

APORIA A Greek word that means "dead end" or "impasse." In some forms of contemporary criticism, especially **poststructuralism,** it refers to the condition of all interpretation, which never reaches a definitive meaning and, hence, is always undecideable or uncertain. See **deconstruction.**

A POSTERIORI Latin for "from the latter." Knowledge that derives from experience or that results from observed facts. See **inductive.**

APOSTLES The original twelve disciples of Jesus (with the betrayer Judas replaced by Matthias) and Paul.

A PRIORI A Latin expression that means "from the former." It is used to describe assumptions somebody takes for granted when advancing an argument, the self-evident propositions he or she feels do not need proving or sometimes that do not depend on experience. See **deductive.**

APSE A usually semicircular and vaulted part of a building that projects from one end. In cathedrals and other church buildings, the apse is usually on the east end facing the **nave.** See **Gothic cathedral.** See Figure 1.

ARAB CONQUESTS The wars beginning in the seventh century A.D. waged by **Islamic** Arabs. Eventually the Arabs conquered most of the Near and Middle East, North Africa, and Spain.

ARCADE A row of connected **arches** and their **piers** or **columns.**

ARCADIA, Arcadian A region in central Greece, used in art and literature to evoke the idealized **landscape** and values associated with **pastoral** poetry. The Latin phrase *Et in Arcadia ego* means "Even I [death] am in Arcadia." See **pastoral.**

ARCH The curved top of an opening, usually made of wedge-shaped blocks wider at the top than at the bottom. Thus, when fitted together, the blocks exert pressure on one another and hold each other in place. The central block is called the keystone. See Figure 5.

ARCHAIC, archaism Used for art and literature that evoke (deliberately or not) an earlier, more primitive time. The archaic smile is the mysterious half-smile found on many Greek statues of the Archaic Age in Greek history (c. 700–500 B.C.).

ARCHETYPE A **mythic image,** story, concrete detail, or **character** believed to represent an aspect of life universal to human beings and originating in their earliest experiences. Being so general, archetypes will appear over and over in many different artistic **media** and literary **genres.** Once believed to be a scientific fact of human **psychology** contained in our "collective **unconscious,**" as popularized by the psychologist C. G. Jung (1875–1961), an archetype is more usefully regarded as a **critical** concept helpful for understanding certain kinds of literary and artistic imagery, stories, and characters and their occurrence over different times and genres, as long as one respects the uniqueness of the individual piece of art or literature and its own historical context. See **myth.**

ARCHITRAVE The part of the **entablature** that rests on the **columns**. See Figure 3.

ARES Greek god of war.

ARIA A solo song in an **opera** or **oratorio**, one usually requiring a high amount of skill on the part of the singer.

ARISTOCRACY, aristocratic Rule by a small group whose status is inherited and based on "blood," a presumed innate superiority of talent, abilities, and qualities.

ARISTOTELIAN, Aristotelean An adjective that refers to the philosophy and ideas of the Greek thinker Aristotle (384–322 B.C.). See **poetics**.

ARS POETICA A name given to a verse-letter by the Roman poet Horace (65–8 B.C.), which sets out principles of **literary criticism,** the most famous and influential of which is that art and literature should "delight and instruct," that is, be **aesthetically** pleasing but carry an **ethical** or moral point as well.

ARTEMIS Sister of Apollo, virgin goddess of the hunt, associated with the moon.

ARTHUR, Arthurian The legendary king of the ancient British. His court at Camelot was home to the finest knights, who sat at a round table ("the knights of the round table"). Arthur and his knights (Lancelot, Gawain, Tristan, Sir Galahad) are characters in many **medieval romances. See chivalry, romance, Holy Grail.**

ART NOUVEAU French for "new art," a style of arts and crafts popular in the late nineteenth and early twentieth centuries featuring decorations based on natural forms.

ARYANS A group of people who invaded India from around 2000–1200 B.C. The term was later appropriated by **racist**

theorists, especially **Nazis,** who postulated that Germanic-Nordic people had spread throughout Europe and western Asia, bringing a superior **culture** to inferior peoples.

ASCENSION After his resurrection, for forty days Jesus appears several times on earth and then ascends into heaven (Luke 24:50–53; Acts 1:9–11).

ASSONANCE In poetry, the purposeful use of the same vowel sounds to form a pattern or merely to make the poem musical.

ATHENA Patron goddess of the city of Athens. Goddess of practical wisdom, associated with warfare and weaving. A huge statue of her in gold and ivory stood in the **Parthenon** in ancient Athens.

ATMOSPHERE In painting, atmosphere refers to the quality of the air that comes between the viewer and distant objects, which appear blurred, indistinct, dim, or hazy. Atmosphere can more generally refer to the dominant emotional or aesthetic quality of a work of art, music, or literature.

ATONALITY Music that does not have a main **key.**

ATTIC An adjective referring to Attica, the region around Athens in ancient Greece, sometimes used to evoke the **culture** of ancient Athens. Also used to identify a style of speaking or writing marked by simplicity, purity, and directness, as opposed to the more flamboyent Asiatic style.

AUSTERLITZ, Battle of Battle fought December 2, 1805 between the French under Napoleon and the Austrians and Russians. Napoleon's victory resulted in recognition of his rule over Italy.

AUTOCRAT, autocratic A person, such as a king, who rules with absolute authority. As an adjective, a government that exercises absolute, oppressive power over its people.

AVANT-GARDE A military term meaning the vanguard of an army, the troops at its head. In literature and art it refers to self-conscious, shocking, and striking innovations in **style**, technique, or subject matter. The avant-garde usually defines itself in opposition to some perceived stuffy establishment stuck in worn-out forms and conventional subjects. However, the avant-garde itself often becomes the establishment, its once fresh innovations hardening into clichés.

BACCHANTE A female follower of the god **Bacchus**, celebrating his rites with frenzied dancing and singing. See **Dionysus**.

BACCHUS Roman name for the god **Dionysus**.

BACONIAN Adjective used to describe or evoke the views of Francis Bacon (1561–1626), the English writer who championed an **empirical** approach to acquiring knowledge, a systematic **method** that would reveal accurate information about the world. He rejected the traditional **medieval** knowledge that was based on scripture and **classical** authorities such as Aristotle. See **New Science**.

BALKANS A region in southeastern Europe bounded by the Adriatic, Aegean, and Black Seas.

BALLAD A short traditional or popular **narrative** song usually arising among illiterate or semiliterate people and transmitted orally.

BALLET A type of dramatic dance with conventional steps and poses combined with athletic leaps and movements. Ballet usually tells a story or evokes an **atmosphere** and is accompanied by music and **scenery**.

BARBARIAN Greek term for non-Greeks, because instead of speaking Greek, they speak something that sounds like "bar-bar-bar." Used especially of the Persians, whose **culture** and **autocratic** government were seen as particularly alien to the Greeks.

BARITONE A singing voice between **bass** and **tenor.**

BAROQUE Refers to a style of painting, literature, and music that arose in and characterizes the seventeenth century, which is sometimes called the Baroque Age. Generally, baroque qualities include extravagant, complex forms and elaborate or even grotesque ornamentation; an interest in emotionalism; monumental grandeur; stark contrasts between artistic elements; dynamic movement; and a tension between simplicity and complexity, and the static and the dynamic.

BARREL VAULT A vault created out of a series of **arches.** See Figure 8.

BASILICA A large building with a wide central aisle (**nave**), side aisles, and an **apse** at one or both ends, used by the Romans for business. Later, Christian churches were designed from this basic plan. See **Gothic cathedral.** See Figure 9.

BASS In music, the lower half of the vocal and instrumental range of **tones.**

BASTILLE A prison in Paris during the seventeenth and eighteenth centuries in which prisoners were kept on orders of the king. It became the symbol of royal **despotism** and was destroyed by a revolutionary mob on July 14, 1789, thus initiating the **French Revolution.**

B.C.E. "Before Common Era." Describes the period usually called B.C. ("Before Christ"). See **C.E.**

BEAT The unit that measures time in music. See **rhythm.**

BEGGING THE QUESTION A logical **fallacy** created when one assumes to be true what is supposed to be demonstrated. Proving the existence of God by quoting the Bible is a crude form of begging the question. Do not use when you merely mean "raising the issue."

BEHAVIORISM A **theory** of **psychology** that believes physical or mental behavior, as measured by responses to stimuli, to be the only legitimate concern of its research. In its radical form, it believes that all behavior is ultimately conditioned by environmental stimuli. See **determinism.**

BEING In philosophy, the term *being* most simply refers to the fact that something exists. It can be further analyzed into abstract being (e.g., ideas, mathematical entities, etc. that exist mentally) and concrete being (e.g., people and things that can be experienced with the senses). See **essence, ontology.**

BELLES-LETTRES, belletristic French phrase referring to literature whose value lies in its **aesthetic** rather than in its practical, intellectual, political, or philosophical value. This term frequently has a negative **connotation,** which is used for literature perceived as politically and socially elitist, insubstantial, artificial, or merely entertaining.

BLACK DEATH The outbreak of bubonic plague in the mid-fourteenth century that killed about one-third the population of Europe.

BLACK-FIGURED See **Greek vase.**

BLANK VERSE See **meter.**

BLUES A type of music developed by African Americans characterized by sad **lyrics,** twelve-bar **phrases,** and three-line **stanzas** in which the second line repeats the first.

BLUESTOCKING An eighteenth-century term for a woman who had intellectual or literary interests not typical of expectations for women at that time.

BOLSHEVIK The name of the radical **socialist** party in Russia from 1903 until the party's victory in the civil war (1921). The Bolsheviks favored revolution over cooperation with more moderate reformers and believed that the presumed engine of revolutionary change, the **proletariat,** needed to be guided from without by a minority party with dictatorial powers—the "dictatorship of the proletariat." See **Russian Revolution.**

BORODINO, Battle of The battle that was fought September 7, 1812 between the French and Russians and that ended with a Russian defeat and Napoleon's occupation of Moscow.

BOURGEOISIE, bourgeois In **Marxist** theory, the social class that owns the means of production and lives off capital rather than physical work or hired labor. More generally, this term is used for the middle class, often negatively, to suggest an over-concern with property and respectability, as well as to imply mediocrity and conformism. See **capitalism, proletariat.**

BRITISH EMPIRE The network of countries throughout the world that in the nineteenth and twentieth centuries were directly or indirectly controlled by England, mainly for purposes of trade and commerce. By the 1960s nearly all of the countries were independent. See **colonialism.**

BRITISH RAJ The British government during the occupation of India (1858–1947).

BRONZE AGE The period of history in which bronze, an alloy of copper and tin, was the material used for weapons and tools. In the ancient Mediterranean, depending on the area, the Bronze Age goes from 3500 or 3000 B.C. to about 1200 B.C. See **prehistory.**

BYZANTINE EMPIRE From Byzantium, the name given to the **Roman Empire** in the East after its capital city, also known as Constantinople. Its art is characterized by religious themes, **mosaics** with brilliant surfaces and stylized figures, intricate ornamentation, and the use of light and reflection to create effects often otherworldly or insubstantial. *Byzantine* is sometimes a negative term suggesting an overcomplex and/or devious manner of operating.

CADENCE In music, a sequence of **chords** that brings the **harmony** to a close.

CAESARS A branch of the ancient Roman Julian clan, whose most famous member was Julius Caesar (100–44 B.C.). The name became a title in the **Roman Empire** established by Octavian (63 B.C.– A.D. 14), later known as Augustus, the grandnephew and adopted son of Caesar.

CALVINISM A kind of Christianity developed from the writings of John Calvin (1509–1564). Its central tenet was **predestination,** the idea that God guides the saved, thus lessening the importance of **free will.** See **Protestantism, Puritanism.**

CANNAE, Battle of A battle during the First Punic War fought between the Carthaginians under Hannibal and the Romans in 216 B.C. The Roman army was nearly annihilated, losing in some reports 50,000 men. See **Punic Wars.**

CANON Simply, a canon is a group of writings considered authentic. Originally the word referred to the books of the Bible thought to be divinely inspired. The word also is used to describe

those works of an author that have been established as authentic, for example, Shakespeare's canon. Today the word has a political charge. To some it refers to those works of **Western** literature that have preeminence and are worthy of being read and taught because they presumably embody timeless values or artistic excellence. Some critics, however, believe that this canon of works represents not any sort of excellence but rather the **ideology** that reinforces the power of the **critical** profession or the dominant political, social, and economic system. In this view, the canon works by creating arbitrary standards of literary "excellence" whose real aim is to exclude any works that challenge an ideology privileging white heterosexual males. Thus, "breaking the canon" is considered a liberating act that opens up the **literary tradition** to voices other than those of the privileged class, race, and **gender.** In music, a canon is a piece of music in which two or more voices successively sing the same **melody** but at a different **pitch.**

CANTATA Music written for a **chorus** featuring a Biblical story and performed in a church.

CANTO A unit of an **epic** or **narrative** poem, used both to divide and to organize the material.

CAPITAL The top of a **column.** The three major kinds of capitals are the Doric, which is very simple; the Ionic, which has a scrolled ornament called a volute; and the Corinthian, which adds acanthus leaves to the volute. See **orders.** See Figure 6.

CAPITALISM, capitalist An economic system in which the organization, ownership, and production of wealth are in private hands, and economic activity is rationalized and based on the investment of capital, which is money that is invested or is intended to be invested in order to create more wealth. In capitalism, economic decisions, production, labor, and prices are left to the free market, in which individuals freely pursue their economic wants and desires, and in which producers compete for customers and

profits without state interference or control. In **Marxist** or **socialist** thought, capitalism is a system of rationalized greed, oppression, and exploitation in which the strong prey on the weak, and **materialism,** property, and acquisition take precedence over human and humane concerns. See **Marxism, socialism, free market.**

CAROLINGIAN RENAISSANCE The revival of learning encouraged by the French king Charlemagne (742–814) or Charles the Great; a movement characterized by an attempt to improve education, foster literacy, establish libraries, and increase the number of books.

CARPE DIEM Latin for "seize the day" or "enjoy the day," from a poem (*Odes* 3.29) by the Roman poet Horace (65–8 B.C.). Sometimes used to describe a type of poetry that advocates living and enjoying life to the full in the present and not worrying about tomorrow because death is inevitable and final.

CARTOON A full-sized drawing done in preparation for a large work such as a **mural.**

CASTALIAN SPRING See **Parnassus.**

CATEGORICAL IMPERATIVE A rational moral law formulated by Immanuel Kant (1724–1804). It states that the principle upon which any proposed action is based must be formulated in such a way that it can become universal, applicable to everybody in similar circumstances.

CATHARSIS The purging or discharge of emotion that comes from viewing art; originally described by Aristotle in *The Poetics* (fourth century B.C.) as the psychological effect of **tragedy,** which arouses the emotions of pity and terror. This discharge is generally viewed as psychologically healthy because potentially destructive emotions are brought to light and confronted in a controlled, fictional setting. See **poetics.**

CATHEDRAL A bishop's church. See **Gothic cathedral.** See Figure 1.

C.E. "Common Era," the period of time once identified A.D. (for *anno domini,* "in the year of the Lord," that is, Christ). Preferred by those who think A.D. privileges Christianity.

CELTIC Refers to the history, society, **culture,** and art of the Celts, the ancient inhabitants of Western Europe. As the Gauls they sacked Rome in 390 B.C. but were ultimately assimilated into the **Roman Empire** or driven to Wales, Ireland, and northwest France (Brittany). They are famous for their **decorative arts,** which are characterized by intricate and complex designs. The druids were the ruling caste that also functioned as priests who conducted ceremonies in groves. In later literature they were given magical powers.

CENTAUR A mythical creature whose chest and head are human but the rest of whose body is a horse. Centaurs are destructively passionate and embody the dual nature of human identity: human **reason** conjoined to animal appetites. To the Greeks they represented those non-Greeks whose minds could not control their passions.

CHAERONEA, Battle of Fought between the allied Greek city-states and Philip II of Macedon in 338 B.C. Philip's victory led to Macedonian dominance over Greece and an end to the independence of the Greek **city-states.**

CHAMBER MUSIC Music written to be performed in a room rather than in an auditorium, using a smaller number of instruments (from three to eight), with all instruments equally important. See **string quartet.**

CHAPEL In a church, a small area set aside for worship, usually in the **ambulatory** and dedicated to a particular saint. See Figure 1.

CHARACTER A person depicted in **drama, fiction,** or another work of art.

CHIAROSCURO Italian for "light-dark." Used to describe the gradual movement from light to dark in a painting, and the use of light and shadow to create shape rather than lines.

CHIVALRY, chivalric An idealized code of conduct associated with medieval knights. It included martial valor and achievement, as well as showing mercy to a defeated enemy; elaborate courtesy or ritualized behavior, particularly when dealing with women; and loyalty and service to one's lord and lady. See **feudalism, courtly love, romance.**

CHOIR The section of a church where the choir sings, usually in back of the altar; also, the people designated to sing in church. See Figure 1.

CHORD Three or more musical sounds played simultaneously. See **harmony.**

CHORUS, choral A group of singers, or a composition intended to be sung by such a group. In Greek **tragedy,** a group of singers and dancers that comments on the dramatic events, often from a traditional or communal point of view. In **Elizabethan drama,** a character who speaks a prologue or epilogue.

CIRCE An enchantress in Homer's *Odyssey* (c. 750 B.C.) who turns Odysseus's men into animals.

CITY-STATE An autonomous **state** consisting of a central city with the surrounding cultivated territory and villages. See **polis.**

CIVILIZATION Used to describe a society that has reached a high level of intellectual, artistic, social, and technological development; a way of life passed on to subsequent generations.

Sometimes used to mean the totality of a particular people's material and mental way of life, which define that people and set them off from others. See **culture.**

CLASSIC, classics Simply, a classic is anything that is the best in its class or that represents its highest standard, especially if it has endured through time. In literature, the classics refer to the writings of the ancient Greeks and Romans, or to those works of a literary tradition considered the best (see **canon**). It is not clear how much time must pass before a work can be considered a classic. We now speak of modern classics, even though this is somewhat of a contradiction, because the jury is still out on whether a work of the last half century will still be read in another fifty years.

CLASSICAL Technically refers to (1) the culture and civilization of ancient Greece or Rome; in reference to ancient Greece, *classical* refers to Greek civilization from around 500–300 B.C.; (2) the music of the late eighteenth and nineteenth centuries, which consciously pursued the values of **classicism** such as order, proportion, and harmony.

CLASSICISM Most basically, classicism refers to the artistic and literary values, techniques, attitudes, and standards derived from ancient Greek and Latin literatures, art, and architecture, especially their few surviving works of **criticism.** Qualities considered typical of classicism include unity of **form** and content, a **style** that is restrained and balanced, a preference for self-controlled reason over exuberant emotion, and a sense of decorum in subject matter. See **neoclassicism.**

CLERESTORY In **cathedrals** and **basilicas**, a row of windows in the upper part of the side wall above the roof of the **side aisles.** See Figure 9.

CLIMAX The highest point of interest or intensity in a work of literature or music; the crisis of the turning point of the **plot.**

CODEX A book made up of bundles of pages, as compared to the earlier form of books, in which a long strip of papyrus paper was rolled up and had to be unrolled as it was read.

COGITO, Cartesian cogito From the Latin translation of a sentence written by René Descartes (1596–1650): *Cogito ergo sum,* "I think, therefore I exist" (*Discourse on Method,* 1637). Although everything can be doubted, one's existence cannot: Merely doubting in itself presupposes existence. To some critics, this assumption puts **consciousness** and **rational** thought in a privileged position over other aspects of human identity, such as the body and emotion; and it implies a stable self with direct access to an **objectively** knowable world. See **rationalism, dualism.**

COLD WAR The struggle between the United States and its allies and the Soviet Union and its satellites in Eastern Europe, beginning in 1945 after **World War II.** Because the two nuclear powers could not risk a full-scale military engagement with each other, the war was fought through allies in **Third World** countries. The Cold War ended in 1990 with the collapse of the Soviet Union and the complete discrediting of **communism,** and its political and economic order.

COLONIALISM One nation's control over smaller, less developed technologically, and weaker peoples who are subordinated (and often exploited) culturally, politically, militarily, and economically.

COLOR In music, the particular quality of **tone,** the unique way it sounds. The same tone made by different instruments will have different color.

COLUMN A round pillar that supports the **entablature** and is topped with a **capital.** See Figures 3 and 6.

COMEDY Originally a type of ancient Greek **drama** featuring physical and verbal humor, obscenity, everyday characters, political and social **satire,** and sometimes fantastic plots. Later

comedy focused as well on love stories in which a boy falls in love with a girl but is kept by various means from possessing her. He eventually wins her, and often the story ends with their marriage. Many of these features characterize modern comedy as well. Comedy usually (but not always) affirms some of a society's values by overcoming the forces that threaten the characters. The marriage at the end suggests that the idealized world depicted in the play has survived and will continue. Comedy is frequently a leveling **genre:** It asserts the common humanity of people (as exemplified, for example, in our universal human needs to eat, have sex, and go to the bathroom) that is obscured by wealth, social prestige, or political power. See **drama, tragedy.**

COMMONWEALTH, Commonwealth of Nations The association of fifty-four independent countries that, with a few exceptions, used to be part of the **British Empire** and that recognize the king or queen of England as their symbolic head. Most of its activities center on promoting cultural and financial relationships among the member nations.

COMMUNE A **medieval** town that had certain rights and privileges, especially of self-governance, taxation, justice, and trade, that were purchased or taken by force from the local aristocracy. In the 1960s, communes were rural communities in which property and work were supposed to be shared equally.

COMMUNISM A social and economic order in which property and the means of production are owned collectively rather than by private individuals; economic and production decisions are made centrally; all aspects of society and **culture** are controlled and policed by the state; and the individual's rights are suspended or ignored. Developed from the writings of Karl Marx particularly by Vladimir Lenin (1870–1924), who led the **Russian Revolution.** See **capitalism, socialism, totalitarianism, Marxism.**

COMPLEMENTARY COLOR Hues are complementary when they contrast sharply placed next to each other but form gray when mixed. The complementary color of a **primary color** is the mixture of the other two primaries. For example, the complementary color of red is green (yellow mixed with blue.) See **primary color.**

COMPOSITION The arrangement and organization of the **forms** in a painting. Also a musical work.

CONCEIT A complicated, shocking, and/or surprising **metaphor.** Also an old word for "imagination."

CONCENTRATION CAMP Generally, a prison where prisoners of war, refugees, or **political prisoners** are detained. More specifically used for the death camps in which the **Nazi** regime methodically murdered and disposed of those peoples, such as the Jews, who were considered subhuman. See **holocaust, Nazi, genocide.**

CONCERTO Music written for one or more solo instruments, accompanied by an orchestra.

CONCRETE Refers to particular, actual things and bodies in the world that can be perceived with the senses. See **abstract.**

CONDOTTIERE A leader of **medieval** mercenary soldiers, especially in Italy during the fourteenth and fifteenth centuries.

CONNOTATION What a word or **image** suggests or implies beyond its literal core meaning. Often this suggested meaning is imprecise. Sometimes what is connoted is an emotion (*red rose* suggests love), or a historical period (as with an archaic word, one no longer in use: *methinks,* for example, conjures up the **Middle Ages**), a political system or **ideology** (*comrade* can suggest **Communism**), or even a social institution (long words derived from Latin, for example, suggest bureaucracies or science).

Good writers consciously manipulate all these connotations to add layers of possible meanings to their words, or to elaborate on the complexity of their ideas.

CONQUISTADORS Sixteenth-century Spanish soldiers and adventurers who traveled to the **New World** and helped conquer the Aztec and Incan empires.

CONSCIOUSNESS, conscious Most simply, awareness of oneself and one's experiences and inner life: memories, moods, dreams, fantasies, emotions, intentions, sensations, ideas, and thoughts. See **unconscious.**

CONSEQUENTIALISM The view that actions are right or wrong depending on their consequences or results. See **absolutism.**

CONSERVATIVE A political view that favors established institutions, social stability, gradual rather than drastic change or reform, traditional social structures, values, and practices, and limited government power over economic activity.

CONVENTION An accepted or traditional practice, technique, or device in art or literature. In ancient Egyptian art, for example, it was a convention to show both eyes even when the face was shown in profile.

COPERNICAN REVOLUTION Refers to the astronomical ideas of Nicolaus Copernicus (1473–1543), whose description of the universe put the sun in the center rather than the earth, as **medieval** science and Christianity believed. See **Ptolemaic.**

COSMOLOGY, cosmological Once a branch of **philosophy** that attempted to give an explanation for the universe as a whole, cosmology now is an activity of physics that tries to understand the structure of space and time in the universe based on Einstein's general theory of relativity.

COUNTERPOINT, contrapuntal Music characterized by a combination of two or more **melodies** that are in **harmony.**

COUNTER-REFORMATION The sixteenth-century Catholic reform movement and response to the **Reformation.** The Counter-Reformation corrected some of the abuses in the **papacy** and church government, created new religious orders such as the **Jesuits,** improved the education of priests, and encouraged spirituality in the church. In terms of art, the Counter-Reformation sought to transmit Catholic **theology** and inspire religious fervor through works of art that were religious, simple, **realistic,** and accessible to the average person. See **Reformation.**

COUP, coup d'état The violent overthrow of a government by a small group.

COUPLET A two-line section of a poem, with the lines usually rhyming. See **sonnet.**

COURTLY LOVE An idealized view of sexuality appearing in the aristocratic literature of the **Middle Ages,** especially after the twelfth century. It is characterized by the exaltation of the beloved lady, the belief in the ennobling power of love to improve the lover morally, the obligation to serve the lady and earn through glorious deeds her favors, an obsession with the experience of physical passion, and making love a quasi-religion. Much of the imagery of courtly love derives from **feudalism.** See also **chivalry, romantic love.**

CRÉCY, Battle of Fought between the English and French on August 26, 1346. As in the battle of **Agincourt,** the English archers proved superior to the French knights. See **Hundred Years War.**

CRITICAL THEORY A school of social criticism developed in Frankfurt, Germany, during the 1930s. Critical theory attacked **capitalist** societies, claiming that their lofty ideals were merely a cover for injustice and greed and the maximizing of corporate power.

CRITICISM, critic, literary criticism The act of consciously explaining, analyzing, and/or interpreting works of art (not just finding fault). Often criticism evaluates works of art, discriminating among them and ranking them in terms of their excellence or worth, and deciding which are superior and which are inferior. Over the years there have been many ways of doing this. Historical criticism interpreted art in order to learn about the period in which it was created. Biographical criticism analyzed works to learn about the artist's life or mind. The **New Critics**, a group of American scholars who flourished around the middle of the twentieth century, believed that literature, especially poetry, should be understood in its own terms as a unified work, all of whose parts related to a **thematic** and **formal** whole, not as a container of messages about society or the life or intentions of the author (see **intentional fallacy**). Instead critics should give close readings of literature, especially poetry, in order to discover that unified meaning through analysis of **structure, theme, imagery, metaphor,** and so on found in the poem itself. This approach sometimes is faulted for being overly concerned with **aesthetics** and, hence, elitist or naive about the **political** ideology some critics believe is expressed in *all* literature, overtly political or not. See **deconstruction, theory.**

CRUSADES Several European expeditions from the eleventh through fourteenth centuries intended to free the Middle East, especially Palestine and Jerusalem, from **Islamic** control. Several European kingdoms were established in what is now Lebanon, Israel, and Syria, all of them eventually being reabsorbed into Islam. The Crusades were marked by brutality against Jews, the sacking of Christian Constantinople (A.D. 1204), and general slaughter, greed, and mayhem. Europe, however, benefited from the economic and cultural contacts established with Islamic culture.

CULTURE Sometimes a synonym for **civilization,** meaning the sum total of a people's particular and identifying way of life. Sometimes in this sense used for more limited subgroups, as in

the expression *gun culture.* More narrowly, culture refers to the system of values and meaning inherent in any people's way of life, especially as these are embodied and transmitted in artistic expression and refinement of life. Related to this definition is the idea of high art, music, and literature (as opposed to **popular culture**). See **civilization.**

CUNEIFORM See **Sumerians.**

CUPID Roman name for the Greek god **Eros.**

CYCLOPES One-eyed giants in Homer's *Odyssey* (c. 700 B.C.). Some were the workmen who helped **Hephaistus** forge the thunderbolts of **Zeus.**

CYNICS, cynicism An ancient Greek **philosophy** begun by Antisthenes (c. 445–c. 365 B.C.) but associated mainly with Diogenes (died c. 320 B.C.). Cynics believed humans need to strip themselves of society's artificial rules and customs and to live naturally—like a dog, hence, the name *cynic* from the Greek word for "dog." Diogenes lived in the street, wore only a loincloth, and urinated and masturbated in public. Today the term *cynical* is used for people who distrust human nature and who believe everything we do is motivated by self-interest.

DACTYL, dactylic See **meter.**

DACTYLIC HEXAMETER The traditional **meter** of ancient Greek and Latin **epics,** very difficult to execute in English, whose epics use other metrical patterns. See **meter.**

DAPHNE Beautiful **nymph** loved by **Apollo.** She was turned into a laurel tree by her father to escape from the god. Thus, he made the laurel wreath the sign of victory for those competing in poetic contests.

DARK AGES A term used to describe Europe from roughly A.D. 500 to 1000 after the collapse of the **Roman Empire** in the West. Usually carries a negative judgment, implying a retreat of learning and **classical** culture and the dominance of the Church over society and the mind. In ancient Greek history, refers to the period (c. 1100–700 B.C.) between the **Mycenean** civilization and the **classical,** "dark" because no written records survive.

DARWINISM, Darwinian In general, the **theory** formulated by Charles Darwin (1809–1882) that species develop by competition for resources, a process that eliminates the least fit to survive ("survival of the fittest"), a process called natural selection. As a **metaphor,** the term *Darwinian* is used for any process in which an amoral competition for ascendency, resources, and power predominates. See **evolution, social Darwinism.**

DECADENCE, decadent Used to describe art, society, or manners that have degenerated from an earlier higher standard, particularly of morals or values. A positive term for those artists and writers who self-consciously are rejecting a traditional morality and value system. See **avant-garde, aestheticism,** *fin de siècle.*

DECONSTRUCTION, deconstruct A style of literary analysis popularized by Jacques Derrida and his theories of how language functions as a system of differences rather than of terms with positive content and fixed meanings hovering somewhere outside the word (see **différance**). Deconstruction assumes that any meaning in a literary work is always postponed by the nature of language itself; what appears to be a meaning is merely an illusive construct created by the system of language and its

operations. All literature, in this view, is like Gertrude Stein's Oakland—there's no "there" there, no meaning, but rather a multitude of linguistic devices and mechanisms that create and sustain the illusion of meaning. Deconstructive criticism sees beyond those devices and through its analysis takes the construct apart—deconstructs it—to reveal the absence that those devices try to conceal or disguise as a positive meaning, as well as uncovering the many other fragments and traces of meanings the literary construct obscures, postpones, or defers. The critic is, thus, free to engage not in analysis for meaning but in a creative performance filled with **puns, allusions,** verbal tricks, and free association of ideas as he or she attempts to recover and make explicit everything the literary construct tries to postpone or hide. Reading deconstructive criticism is sort of like watching an improvising stand-up comic explain how a magician performs illusions at the same time he is doing them. Deconstruction has been criticized, especially by **historicist** critics, for being a clever and self-indulgent **formalist** analysis that ignores the **political** or historical context of a poem, play, or novel. See **poststructuralism, theory, criticism.**

DECORATIVE ARTS Items intended to be worn or used, especially jewelry.

DEDUCTION, deductive A type of argument that assumes in advance certain propositions are true and certain conclusions must thus follow those propositions. See **a priori.**

DEMETER Greek goddess of grain, agriculture, and fertility.

DEMOCRACY, democratic Literally "rule by the people." In ancient Athens, where democracy reached its most radical form, all citizens participated in running the state at all levels—executive, deliberative, and judicial. Today democracy is more loosely used to describe any government in which supreme power is vested in the people, and citizens enjoy freedom and guaranteed **rights,** even if they rule through representatives they elect. See **republic.**

DESPOTISM Absolute power in the hands of one person, especially when that power is oppressive and abusive. See **absolutism, tyranny.**

DETERMINISM, deterministic Any theory that considers outcomes to be determined in advance—that they are the effects of earlier causes (history, geography and climate [environmental determinism], genes, social organization, etc.) and, hence, cannot be freely altered. For example, historical determinism (such as the **Marxist** view of history) understands historical events not as the result of the free decisions made by human beings but rather as necessarily determined by larger, impersonal forces that obey their own laws, such as economics or social class. See **behaviorism, free will.**

DEUS EX MACHINA Latin for "the god in the machine." In Greek **tragedy**, an actor portraying a god would sometimes appear over the stage in a crane (the machine). This god would sometimes wrap up the story or provide it with a resolution. The phrase *deus ex machina* is sometimes used negatively about some artificial or arbitrary device (a character or **plot** twist) whose only purpose is to bring a story to a close or provide a solution to a problem.

DIALECTIC, dialectical The question-and-answer method of Socratic discussion, in which statements are subjected to further questioning in order to test their validity or coherence. Later, an idea of history (the dialectic of history) in which events progress through a process of conflict. Two ideas or forces will clash (the thesis and antithesis) until a synthesis develops that transcends both.

DIALOGUE The transcript of conversations between characters in literature, especially **drama.** In the **philosophy** of Plato, a form of composition in which philosophical issues are explored through the imagined conversations of two or more characters.

DIANA Roman name for **Artemis.**

DIASPORA Term used mainly to describe Jewish communities and **culture** after the destruction of Jerusalem by the Romans in A.D. 70 and the subsequent scattering of the Jews. Now used for other ethnic groups that have been forcibly removed from their homes, such as the descendents of slaves sold from Africa.

DICTATORSHIP OF THE PROLETARIAT See **Bolshevik.**

DICTION Refers to the particular choice of words in literature.

DIDACTIC POETRY A **genre** of poetry that teaches or provides practical information about subjects such as astronomy, farming, mathematics, rhetoric, and especially **philosophy.**

DIFFÉRANCE A French word coined by Jacques Derrida to describe how he believes language works to make a definite and stable meaning impossible. Basically the term combines the ideas of difference and deferral. Words can have meaning only because they "differ" from one another in the larger system of language; thus, all the elements of the system contribute to the presumed meaning because *cat* makes sense only because it is different from *rat* and *bat,* and because the latter words are deferred or postponed or put off. The sense of the word, then, resides in the whole system and its dynamic of difference and deferral, not in the individual word. But those other words and meanings, according to Derrida's theory, hang around like verbal ghosts haunting the word and complicating or obscuring its presumed meaning with their traces. See **deconstruction, sign, structuralism, poststructuralism.**

DIONYSUS Greek god of wine, the irrational, and the loosening of social and **rational** constraints. Associated with pine trees, grapes, and ivy. He was worshiped by **maenads** in orgiastic rituals.

DIVINE RIGHT A doctrine that held kings to be chosen by God; thus, resistance to a king or his commands was considered a sinful violation of God's will.

DOMINANT The fifth note in a **major** or **minor scale.**

DRAMA A kind of literature (also called a play) that portrays life and characters through **dialogue** and intended usually to be acted publicly in a theater. See **comedy, tragedy.**

DRAMATIC IRONY See **irony.**

DRAMATIS PERSONAE Latin for "the **characters** of the **drama**": a list of the chracters that will appear in a play. See **drama.**

DUALISM, dualistic The idea that mind and body are two separate and distinct entities, the former immaterial and rational, the latter material, irrational, and appetitive. Dualistic refers to anything characterized by a stark contrast between two opposed elements, such as light and dark or good and evil.

DYNAMICS In music, refers to the variation or contrast in the force or intensity of the sound.

DYSTOPIA, dystopian An imaginary world, usually set in the future, described as worse and more depressing than ours. See **utopia.**

EAST-WEST SCHISM The division between the Catholic Church and the Eastern Orthodox Church, which was formalized in A.D. 1054. The main differences centered on the authority of the Pope and the role of the Holy Ghost in Christian **theology.**

EDWARDIAN Term used to describe the **culture** and art of England during the reign of Edward VII of England (1901–1910).

This period between Queen Victoria's reign and World War I, is often characterized in terms of material abundance and complacency. See **Great War, Victorian.**

EGO See **Freudianism.**

ELEGY, elegiac A poem whose **theme** is death or some other somber subject upon which the poet medidates. In the sixteenth and seventeenth centuries the term was also used to describe poems about a lover's troubles, but later elegy described poems about death, especially the death of someone dear to the poet. Elegy is characterized by a serious and reflective mood. Percy Shelley's poem about the death of John Keats, "Adonais" (1821), is a good example of English elegy.

ELIZABETHAN A term used to describe and characterize English art and society during the reign of Elizabeth I (1533–1603), particularly theatrical **drama.**

EMPIRICAL, empiricism Most simply, empirical means that something is based on experience. Empirical knowledge or empirical evidence is knowledge or evidence acquired through the five senses. Empricism, associated primarily with the British philosopher John Locke (1632–1704), is the view that true and reliable knowledge is acquired through the senses and experience that "write" information on the mind, which is a *tabula rasa,* a "blank slate." The only way we can gain knowledge of the world is through neutral observation that does not attempt to shape the information the world sends us in order to fit a preconceived idea.

ENGRAVING A **print** made by cutting a design into a metal plate; ink is forced into the cuts and then the plate is pressed onto paper.

ENLIGHTENMENT, the A historical and philosophical movement of the eighteenth century, particularly in France (hence, the

eighteenth century is sometimes called the Age of Enlightenment). The Enlightenment **philosophy** was characterized by (1) a high value placed on individual human reason and rational activity as the defining quality of humans; (2) all humans by nature are rational and so, absent warping social and cultural forces, can be and do good; (3) this rational human nature is universal and defines all people; hence, individual liberty and equality are prized; (4) **progress** and improvement in human life and society are possible; (4) secularism: **rationalism** rather than religion or irrational custom should organize society and establish its goals; (5) tradition, whether religious or ethnic, is usually a repository of irrational superstition and prejudice and should be rejected in favor of rational truths; hence, there is a decided antiauthoritarian flavor to Enlightenment thought; (6) finally, a high value placed on educating as many people as possible so that their rational capacities, warped by traditional and religious superstition, can be developed and improved. According to Immanuel Kant, the motto of the Enlightenment was *Sapere aude*—"Dare to know" [in "What Is Enlightenment?" (1784)]. The birth of **philosophy** and **rationalism** in fifth-century Athens is sometimes called the Athenian Enlightenment.

ENTABLATURE The horizontal part of a building that rests on the **columns.** It consists of the **architrave**, the **frieze,** and a cornice on the top, which usually projects. See Figures 3 and 6.

EPIC A long story in verse retelling the adventures of warrior **heroes.** Homer's *Iliad* (700 B.C.), Vergil's *Aeneid* (19 B.C.), and the *Song of Roland* (1100 A.D.) are all epics of this sort. Later the term comes to designate any work of literature or even film that is long, comprehensive in scope, and elevated in **style** and **theme.**

EPIC OF *GILGAMESH* A 3,000-line **epic** poem dating from around 2000 B.C., recounting the adventures of the Sumerian king Gilgamesh. The epic contains a flood story thought to have influenced the Biblical one.

EPICUREAN, epicureanism Ancient Greek philosophy created by Epicurus (341–270 B.C.). Epicurus believed that everything, even the soul and the gods, is merely material atoms in motion, which combine randomly to create all that exists. Because the soul died with the body, and the gods were indifferent to human behavior, happiness consisted in making **rational** choices that weighed the immediate pleasure and pain attending any decision or action. Thus, Epicureanism taught withdrawal from the political and public worlds, which are arenas of pain that one cannot control. Often confused with **hedonism,** Epicureanism recognized that most pleasures of the body or appetites were attended with pain that outweighed the pleasure. Hence, Epicureans actually lived frugally, pursuing the pleasures of the mind shared with fellow Epicureans.

EPIGRAM A brief poem that has one punchy point, either satirical, complimentary, or insightful.

EPIPHENOMENON, epiphenomena A phenomenon that accompanies another phenomenon and is caused by it. A crude example would be the simplistic **Marxist** idea that a society's art and culture are mere epiphenomena of economic organization or the means of production.

EPISTEMOLOGY, epistemological, epistemic Epistemology is the **theory** or systematic study of knowledge—how we acquire it, what its sources and nature are, how accurate or reliable it is, and what its grounds and validity are. *Epistemic* is a more general word that refers to knowledge or knowing. These two terms should not be confused.

EPITAPH A brief poem suitable for a gravestone or monument. Do not confuse with *epigraph,* a quotation that prefaces a piece of writing.

EROS Greek god of sexual desire, son of **Aphrodite** and in some traditions **Ares,** usually pictured as a young boy with a bow and arrows: The golden arrows incite desire, the lead ones deflect it.

ESSAY A brief piece of writing that explores a topic from the author's point of view. A **genre** created by Michel Montaigne (1533–1592) whose *Essays* were published starting in 1580.

ESSENCE The defining characteristic of a thing; what is necessary for that thing to be what it is. See **being.**

ETCHING A **print** made by scratching a design onto a ground (a material that resists acid) spread on a metal plate, which is then dipped into acid that eats away the metal exposed by the scratches.

ETHICS The discipline that considers issues of good and bad conduct, including moral duty and obligation, and that sets out our principles of conduct. Sometimes used to describe a more limited set of principles and values that governs a group, such as professional ethics.

EUCHARIST The act of Communion in Christianity, the rite whereby the communicants eat bread and drink wine **symbolizing** the body and blood of Jesus Christ; in Catholic Christianity, the bread and wine actually are the body and blood of Christ through the miracle of transubstantiation: the substitution by the priest of the **essence** of the bread and wine with the essence of the body and blood of Christ.

EVOLUTION In general terms, a concept that focuses on how things change and develop through time, usually from a simpler to a more complex stage, in terms of consistent laws and processes. Most frequently associated with Charles Darwin and the theory of evolution, which attributed the variety of species and their forms to adaptations through time selected for their survival value by environmental pressures acting on the random mutations that create the adaptations (natural selection). See **progress, Darwinism.**

EXISTENTIALISM, existential A twentieth-century **philosophy** [usually understood in the version of Jean-Paul Sartre

(1905–1980)] that starts with the **subjective,** physical reality of the individual and the conditions and limitations of his or her existence. Humans are thrown into an alien, unfathomable, inhuman, and uncaring world that offers no sure guidance for human conduct or action. Nonetheless, people must take responsibility for their free choices, actions, and commitments because they are defined by these, and they must be honest with themselves and others about the conditions and limitations of their lives and the world and the consequences of their choices. To accept this responsibility is to be authentic, and to avoid this responsibility is an act of bad faith. See **absurd.**

EXPRESSIONISM An artistic and literary movement of the early twentieth century that focused on the violent expression of emotion and that disdained **realism** and **aesthetic** values.

FALL, the In Christian **theology,** the expulsion of the first human beings Adam and Eve from the Garden of Eden because they disobeyed God and ate of the fruit of the Tree of Knowledge of Good and Evil. See **original sin.**

FALLACY, fallacious An invalid but plausible argument usually based on a false move from one truth to another. Also a particular kind of erroneous or invalid argumentation, such as **begging the question,** which assumes something to be true that is supposed to be proven to be true. Do not use "begging the question" when you just mean "raising the issue."

FALSE CONSCIOUSNESS A **Marxist** term that refers to the way people's thinking is shaped by social **ideology** or class biases

of which they are unaware. Sometimes used more generally of people who hold ideas that they do not realize are the result of larger social forces and ideologies. See **Marxism.**

FANCY Old word for "imagination."

FARCE A type of performance that just wants to make the audience laugh; usually characterized by physical humor, confusion, disguise, exaggeration, vulgarity, and so on. Farce differs from **comedy** by its lack of a serious point or **idea.**

FASCISM A political philosophy dominant in Europe between **World War I** and **World War II** (1919–1945), particularly in Italy and Germany. Fascism combines radical ethnic **nationalism**—an irrational attachment to a particular **culture** and way of life and a scorn or even hatred of different cultures—with centralized state control over all aspects of life. Power is usually in the hands of an authoritarian, charismatic leader such as Benito Mussolini (1883–1945) or Adolf Hitler (1889–1945). **World War II** effectively ended fascism, yet the term is still used today, usually incorrectly, to mean antisocialist or authoritarian.

FATE, fatalism In ancient Greek literature, fate is a sequence of future events, usually culminating in death or disaster, known to the gods and often communicated to mortals. Fatalism is the belief that future events are already determined and humans are powerless to change them.

FAUN In Roman myth, a half-goat, half-man, lustful creature frequently associated with **Bacchus.** See **satyrs.**

FAUSTIAN From Dr. Faust, a legendary German scholar who sells his soul to the devil for twenty years of knowledge, pleasure, and power. Best known from the English play by Christopher Marlowe (1564–1593), *Dr. Faustus* (published 1604). An adjective used to suggest the mortal dangers that attend

the excessive, arrogant pursuit of knowledge and power over nature at the expense of spiritual values.

FEMINISM, feminist Most generally, feminism comprises (1) the idea that women should be given the same economic, legal, and political rights as men; and (2) the attempt politically to achieve this goal. This version is sometimes called equity feminism. A stronger version, sometimes called **gender** feminism, sees the sexes as radically different in mentality and values and, thus, views the relations between the sexes as necessarily characterized by male oppression, exploitation, subordination, and inequality. The adjective *feminist* is sometimes attached to activities such as **criticism** or **philosophy** that interpret art or ideas in terms of some or all of these feminist assumptions.

FERTILE CRESCENT A region of the Middle East starting with the Nile River Valley and extending east along the Mediterranean to the Tigris-Eurphrates Rivers, ending in the Persian Gulf. The earliest **civilizations**—those such as the Egyptian and Sumerian civilizations possessing writing, monumental architecture, agriculture, and complex social and political organizations—arose in the Fertile Crescent.

FEUDALISM, feudal Historically, a social and political structure during the European **Middle Ages** in which society was organized in a vertical hierarchy, with each man (a vassal) bound by oath to the one above him (his lord) by homage (service) and fealty (loyalty). For aristocratic warriors this service was usually military; for peasants service entailed contributions of agricultural produce and labor. In exchange the warrior was granted material support usually in the form of land, which he could rule and tax (a fief), and the peasant was granted protection. The feudal view of society is static (people are born into their social class and have very little opportunity of leaving it), authoritarian (respect and service are owed without question to those higher up in the social scale merely because they are

higher up), militaristic (warriors are privileged), agricultural (land is the most important form of wealth), and personal (social relationships are determined by oaths and mutual obligations between persons, not by abstract political organization or codes). As an adjective, *feudal* is often used to describe non-**Western** social and political organization that contains the elements of Western medieval feudalism. See **chivalry.**

FICTION A story that is made up rather than historically true. All literature is fiction in that its characters, stories, and events are created out of the imagination of the author. Sometimes real people or historical events appear in literature, but the overall production is still a fiction. Be careful not to assume that fiction means "untrue." A **novel,** for example, though technically not true in its events or characters, can still offer philosophical or **psychological** truths.

FINAL SOLUTION Euphemism used by the **Nazis** to describe the **holocaust.**

FIN DE SIÈCLE French for "end of the century," a term used to describe the late nineteenth century, particularly in regard to the fashionable artistic attitudes of world-weariness and despair. See **decadence.**

FLAT Sign placed before a **note** to show that it should be lowered a half step. Also more generally a **tone** that is sounded below its proper **pitch.** See **note, pitch, tone.**

FLYING BUTTRESS See **Gothic cathedral.** See Figure 10.

FOCAL POINT In a painting, the spot that the viewer's eye tends to focus on or to be directed to.

FOIL A **character** who serves as a contrast to another, thus setting off and accentuating that character's qualities. If the foil is funny or silly, he or she is a comic foil.

FOLKLORE Traditional customs, songs, stories, sayings, or kinds of art associated with a particular people and usually transmitted orally.

FOLK MUSIC Traditional songs characterized by **stanzaic** form, a **refrain**, and simple **melodies**. Frequently concerned with adventure, tragic romance, and the supernatural. See **ballad.**

FOOT The unit of measurement used in analyzing **meter.** See **meter.**

FORESHADOWING A literary device that anticipates, refers to, or suggests a future event, often indirectly or **symbolically.**

FORESHORTENING A way of showing objects in a painting as if they were seen from an angle and moving away from the viewer rather than from the front or the side. See Figure 7.

FORM The design and organization of a work of art, music, or literature; the arrangement, pattern, or **structure** of its elements, whether these be words, events, **images,** scenes, and so on in literature; or **line,** shapes, or colors in art; or sound, **rhythm, tone, melody, harmony** in music. Also refers to the bodies and objects in a painting.

In **Platonic philosophy,** form is the translation of what Plato called the **idea,** the essence of a thing or concept apart from any particular example of it (Platonic form, Platonic idea). Plato's theory of forms postulates a realm in which abstract, immaterial types or kinds of things and concepts, available not through the senses but through rational thought, exist apart from any concrete instance of the type. Thus, even if all the horses in existence were destroyed, the idea or form of horse—the abstract characteristics and qualities all horses possess that allow us to indentify a four-footed creature as a horse in the first place—would still exist and be available to thought. Aristotle differed from Plato by limiting the existence to a rationally recognizable abstract form to its specific instance. See **idea, Platonic.**

FORMALISM, formalist A kind of **criticism** that concentrates on the form of the literary or artistic work—its shape as created by the **genre** to which it belongs, language, color, subject matter, **style, imagery, meter,** plot, and so on, rather than focusing on the historical context, **politics, ideology,** or anything outside of literature and the individual work. Hence, formalist criticism is sometimes faulted for being a high-toned, elitist activity unconcerned with more important issues of political **power** or social justice. See **criticism.**

FORTUNA Latin for "chance" or "luck," whether good or bad. In **medieval** and **Renaissance** art and literature Fortuna becomes a **personified** goddess who represents the amoral, random way material **goods** are distributed in this world. See **wheel of fortune.**

FOUNDING FATHERS, Founders The fifty-five delegates to the convention that drafted the U.S. Constitution in 1787. Sometimes used for the writers who debated and discussed in print (such as *The Federalist* papers) the philosophies and principles of government.

FRANKENSTEIN, Frankenstein's monster A **character** from a **novel** by Mary Shelley called *Frankenstein* (1818), about a doctor who gives life to a creature that he has assembled. *Frankenstein's monster* (more frequently, but incorrectly, *Frankenstein*) is used **metaphorically** for **technology** or scientific research that has unforeseen disastrous consequences.

FRANKS Germanic tribes that took over **Gaul** in the midfourth century and started the French nation.

FREE MARKET Economic activity that is not regulated or controlled from without, especially by the government, but that operates through free competition. See **capitalism, invisible hand.**

FREE VERSE Poetry that is not written in any traditional or formal metrical pattern. See **meter.**

FREE WILL The idea that humans have the ability to choose freely their actions and ends, no matter what other constraints are at work. See **determinism.**

FRENCH REVOLUTION The violent uprising that eventually ended the **monarchy** and aristocratic rule in France in 1789. A National Assembly was created, a new Constitution written, the Church lands nationalized, and the country divided into departments governed by locally elected assemblies. After an attempt to keep the monarchy in a more limited role, in 1792 it was abolished and a year later Louis XVI (1754–1793) was executed. Constant factional fighting and attack from other European powers kept a stable form of government from being created, and the Revolution was ended by Napoleon's seizure of power in 1799. See **Terror, Reign of.**

FREUDIAN, Freudianism Refers to the theories and ideas of the psychologist Sigmund Freud (1856–1939). Freud believed that personality was the result of early traumatic experiences that had been **repressed** from **conscious** awareness but that lived on in the **unconscious** where they continued to affect behavior and were **symbolically** expressed through neurotic behavior, slips of the tongue (Freudian slips), and particularly dreams. Most of these experiences involved the child's relationship to his or her father and mother, especially the child's sexual feelings for the mother or father and the ensuing competition for the mother's or father's affection and attention, with the other parent, who becomes a hostile and threatening figure. Freud described the human psyche or identity as containing the **ego,** the conscious mediator between self and reality; the **superego,** the internalized rules and authority of the parent that monitor behavior and rewards or punishes with emotions and attitudes such as guilt; and the **id,** unconsious, irrational energy, especially sexual. As an adjective, Freudian describes criticism that is based on Freud's psychological theories and that interprets works of art from that standpoint. See **conscious, unconscious, repression, libido, Oedipus complex.**

FRESCO A painting made on wet plaster, usually on walls or ceilings. The **pigments** dry with the plaster and become part of the surface.

FRIEZE The part of the **entablature** between the cornice and the **architrave**. Sometimes decorated with sculpted scenes or ornaments. Also any sculpted or ornamented horizontal band. See Figures 3 and 6.

FUGUE A kind of music consisting of two to five parts, one of which states a **theme** taken up by the other parts. See **counterpoint**.

FUNCTIONALISM An architectural theory that subordinates a building's design to its function or purpose.

GALLEYS A warship powered by oars, used for nearly four thousand years, especially in the Mediterranean. The Greek galleys, called **triremes**, fought by ramming the enemy ship. By the Roman period, soldiers would board enemy ships, and by the sixteenth century galleys were fitted with cannon.

GAUL, Gauls The Roman name for the land (roughly modern-day France, Belgium, and Switzerland) inhabited by the **Celts**. The territory was conquered by the Romans, pacified by Julius Caesar (59–49 B.C.), and made a province of Rome.

GENDER In grammar, gender refers to whether nouns are masculine, feminine, or neuter. In criticism of a **poststructuralist** bent, gender refers to the ideas of male and female as generated not by nature or the body but by linguistic, **cultural**, and social systems that construct male and female and their defining

characteristics in ways that legitimize one sex's **power** and privilege at the expense of the other. See **structuralism, poststructuralism, historicist.**

GENEVA CONVENTIONS A series of agreements, the first in 1864, that govern behavior during wartime. They protect the wounded and medical personnel, and prohibit the torture and killing of prisoners and civilians, mass deportations, hostage taking, mass reprisals and punishments, and the use of chemical and biological weapons.

GENOCIDE Literally means "murder of a race." Used for the planned, systematic, organized murder of racially or ethnically distinct peoples in order to eliminate the race or ethnic group completely. See **Nazi, holocaust, final solution, concentration camp, racism.**

GENRE, generic A kind or type of literature, art, or music defined by **form** or sometimes subject matter—**epic** represents a genre, as does the **novel.** In music, a **symphony** is one kind of music, a **quartet** another. In painting, a **portrait** is one genre, historical painting another. Also in painting, a genre scene is a representation of daily life that does not have any further religious or **symbolic** purpose. These genre classifications used to be thought to transcend individual works and to be a means for understanding and defining them. Today genre categories are still useful for describing and grouping individual works across historical periods and national literatures, but many critics are suspicious of the claim that genre categories refer to some timeless essence of a work of art or music. On the contrary, artistic and musical works and genre categories as well are too bound up in a historical, political, and cultural context to have any sort of transcendent timeless identity.

GLORIOUS REVOLUTION The peaceful establishment of constitutional government and limited **monarchy** in England from 1688 to 1689.

GNOSTICISM, gnostic From the Greek word for "knowledge." A highly **dualistic** form of early Christianity (second through fourth centuries A.D.) characterized by the belief that matter is evil and the spirit (mind) good, and that **redemption** is achieved through austere living and a secret knowledge known only to a few. See **Manichaeism, Platonism, Neoplatonism.**

"GOD IS DEAD" The way German philosopher Friedrich Nietzsche (1844–1900) described the retreat of Christianity, and the idea of God as the ultimate ground of meaning, before the success of science and the scientific worldview in the nineteenth century. See **Nietzschean.**

GOLDEN AGE A myth that views the distant past, usually characterized as a time before technology and urban life, as superior both morally and materially to the wicked, corrupt present. See **Iron Age.**

GOOD, the; goods In Greek **philosophy,** the good is the suitable and appropriate goal or end toward which something or someone strives, possession of which will make that person achieve happiness or well-being, a state of contentment in which one feels that nothing is lacking. Usually the good involves an activity or function. Thus, the good for a hammer would be driving nails, and a hammer could be said to be "happy" when driving nails. For human beings, the suitable good is **rational** and must involve a rational activity. All other goods—those of the body or appetites that we share with animals—are false, inappropriate, or not ones essentially human, and their possession will not make a person happy.

GORGON In Greek myth, female monsters whose look could turn people into stone. Medusa is the most famous gorgon.

GOTHIC As a historical term, an adjective that refers to the Goths, a Germanic tribe (divided into Ostrogoths and Visigoths) that starting in the third century A.D. infiltrated and overran the **Roman Empire.** In literary studies, this term usually refers to a

type of fiction that arose in the late eighteenth century and expressed many of the same concerns as **romanticism,** especially an emphasis on the strange, the mysterious, and the irrational, particularly terror and the erotic; hence, Gothic is opposed to many of the assumptions of **classicism.** Gothic **novels** frequently focus on dark and wild settings such as forests and **medieval** castles, places where sinister figures pursue attractive young girls and conceal ancient crimes. Gothic is concerned with **atmosphere** and mood and creating an emotional charge pleasurable to the reader. One can say that Gothic sexualizes terror, so that both powerful emotions reinforce and intensify one another and the reader's pleasure at vicariously experiencing both. Emily Brontë's *Wuthering Heights* (1847) is perhaps the high point of the Gothic novel in English. Today's slasher films represent a degenerate form of Gothic. See **romanticism.**

GOTHIC CATHEDRAL A kind of church architecture that developed in northern France in the middle of the twelfth century A.D. Its characteristics include spatial grandeur, both in the interior space and the building's height; the manipulation of light and color through an extensive use of stained-glass windows; pointed arches; a delicate, rhythmic framework of supporting pillars and decorative patterns from story to story; cross-ribbed vaulting, domes made of two pointed arches set perpendicular to one another (see Figure 11); and **flying buttresses,** exterior stone props that supported the weight of the walls and roof. See **Romanesque.** See Figures 1 and 10.

GRAND INQUISITOR The head of the Spanish **Inquisition.** The first Grand Inquisitor was Torquemada (1420–1498). His methods, including torture and burning at the stake (the *auto-da-fè*), made his name a **symbol** of institutionally sanctioned intolerance and cruelty. See **Inquisition.**

GRAND OPERA A kind of **opera** characterized by seriousness (as opposed to light or comic opera), singing throughout, and a large cast with full orchestra.

GRAPHIC ARTS All the forms of art such as **woodcuts, engravings, etchings,** and so on, in which **line** and shape are more important than color.

GREAT DEPRESSION, the Global economic crisis that began with the crash of the U.S. stock market in October 1929, and whose effects lasted throughout the 1930s. In the United States, by 1932 nearly every bank was closed and 14 million people were unemployed. See **New Deal.**

GREAT WAR, the Another term for **World War I** (1914–1918).

GRECO-PERSIAN WARS See **Persian Wars.**

GRECO-ROMAN Adjective that refers to the history, culture, literature, and art of ancient Greece and Rome. See **classical.**

GREEK VASE A type of pottery produced in ancient Greece, usually decorated with mythological **characters** or **scenes,** or with scenes from everyday life, such as drinking parties (**symposium**). In black-figured vases the males are black; in red-figured vases the males are red.

GREGORIAN CHANT Also called plainsong. The chant, usually in Latin, used during Roman Catholic Church services, sung in a single **melody** and following the **rhythm** of the words.

GROIN VAULT A ceiling made of two **arches** set at right angles.

HADES Greek god of the underworld; also a name for the underworld where the spirits of the dead resided.

HAIKU Japanese form of poetry with three lines and seventeen syllables; the first line with five syllables, the next with seven, and the last with five. Traditionally haiku focused on nature and a specific season.

HALF-RHYME See **rhyme.**

HARMATIA See **tragic flaw.**

HARMONY The combination of simultaneous **notes** to form a **chord**, especially when the resulting sound is pleasing. Also the **structure** of music in respect to the progression of chords and their relationship to one another.

HASTINGS, Battle of Fought October 14, 1066 between the English and the invading French **Normans.** The Norman victory established their rule in England.

HEBRAIC, Hebraism Hebraic refers to the **culture,** religion, or history of the ancient Jews or Hebrews. *Hebraism* is a term popularized by Matthew Arnold (1822–1888) in his *Culture and Anarchy* (1869), where he used *Hebraism* to describe cultural values that center on humanity's obedience to a moral code and need to seek moral improvement. See **Hellenism.**

HECTOR The foremost Trojan warrior during the **Trojan War.** He is killed by **Achilles.**

HEDONISM, hedonistic The belief that pleasure, whether physical or **psychological**, is the **good** for humans either individually or collectively.

HELEN In Greek legend, the most sexually beautiful woman in the world, whose elopement with **Paris** started the **Trojan War.**

HELLENIC An adjective used to describe ancient Greek culture and civilization.

HELLENISM Generally, the **humanistic** and **classical** ideals associated with ancient Greece, including **rationalism** and a focus on human life and abilities rather than on the gods. Matthew Arnold used this term to define the other influence on **Western** culture besides **Hebraism:** a focus on the human pursuit of knowledge and the enjoyment of life.

HELLENISTIC Period in Greek history from the death of Alexander the Great (323 B.C.) to around 100 B.C.; the Greek culture of this period and beyond that influenced the Romans.

HEPHAISTUS The lame craftsman god of the Greeks, who makes all sorts of contraptions as well as the thunderbolts of **Zeus.** Married to **Aphrodite.**

HERA The queen of the Greek gods, wife/sister of **Zeus.** Frequently jealous over her husband's many love affairs.

HERACLES A legendary Greek **hero,** the son of **Zeus,** who must perform twelve tasks (the labors of Heracles). Frequently depicted with a lion's skin and a club. Later a figure of comic appetitive excess.

HERCULES Roman name for **Heracles.**

HERMENEUTICS, hermeneutics of suspicion This term once was used to refer to the "science" of interpreting religious works, particularly for their **allegorical** rather than literal meaning. Now hermeneutics describes and analyzes the procedures, methods, and techniques of interpreting literature for meaning. The term *hermeneutics of suspicion* refers to a **theory** and practice of interpretation, which assume the literary work has something to hide, that something usually being the work's own absence of any positive meaning (see **deconstruction**); or its exclusion of some socially, economically, or politically oppressed group. See **historicism, poststructuralism, theory.**

HERMES The Greek messenger god; also a trickster and the god of thieves. He escorts dead souls to the underworld. Sometimes shown with the caduceus (a stick twined with serpents) and winged sandals.

HERO The central **character** of a story, particulary an **epic** poem, a **tragedy**, or a **novel.** The literary hero is not necessarily morally superior, usually being a mixture of good and bad qualities. He or she is, however, the focus of the story. See **antihero, tragic hero.**

HEROIC COUPLET A verse form consisting of two lines of **iambic pentameter** whose last syllables **rhyme.** A very common verse form often used for philosophical or narrative poetry. Alexander Pope is one of the masters of the heroic couplet, as in the following famous couplet from the *Essay on Man* (1733): "Hope springs eternal in the human breast:/Man never Is, but always To be blest." See **meter.**

HEURISTIC Used for a **critical** device or technique that helps us to understand, explain, or discover meaning.

HEXAMETER See **meter.**

HISTORICISM, historicist, new historicism In history, the belief that truth will be found not in abstract or universal **theories** but rather in **concrete** events understood in their specific origins and development in space and time. More generally, the idea that concepts, beliefs, standards, and so on can be understood only in the context of the larger **culture** of their time. Also a type of **criticism** that locates an artistic work in its social, historical, economic, and especially political context. A type of literary criticism called the new historicism differs from historical criticism (which related a work to its historical context, the events, peoples, and society of its time) in that new historicism finds reflections of **ideological** or **political** values and hierarchies embedded in the work's **form, theme,** and meaning. Usually this ideology is one

that economically and politically privileges some groups over others that are excluded from political **power**. This process of privileging and excluding is expressed in the literary work at every level. The fundamental assumption is that all a society's productions from art to advertisements are ultimately shaped by the underlying relations and mechanisms of political power and privilege and, hence, can be related to each other in these terms. (A crude example would be an interpretation of Shakespeare's *The Tempest* [1610–1611] that asserts the play is a reenactment and justification of nascent European **colonialism**.) This process is uncovered by the historicist critic, who relates the literary work to other cultural productions outside of literature, especially marginal or obscure ones. Historicism is, thus, opposed to any sort of **formalist** or **aesthetic** approach that interprets a work solely in terms of its literary values or its own generic or authorial concerns. See **deconstruction, politics, power.**

HISTORIOGRAPHY The study of how history is written and of historical scholarship; the principles, **theory**, and history of historical writing.

HOLOCAUST In the ancient world a word used to describe a sacrifice in which the victim was completely burned. The modern term for identifying the systematic murder of 6 million Jews and millions of other peoples by the **Nazis** (1933–1945). See **concentration camp, racism, Nazism, genocide, final solution.**

HOLY GHOST, Holy Spirit In Christian belief, one of the persons of the **Trinity**, frequently represented as a dove. The Holy Spirit is embodied in Jesus and his teachings during his life and distributed to the believers through him after his death.

HOLY GRAIL The cup used by Christ in the Last Supper. Frequently an object sought after by knights in **medieval romance**, for the Grail is believed to have redemptive and creative powers. See **romance**.

HOLY LAND A Christian term used to describe modern-day Israel, location of the significant events of Christian history such as the birth of Christ and the Crucifixion.

HOLY ROMAN EMPIRE An empire covering central European territory between France in the west, Poland and Hungary in the east, and Italy north of Rome in the south, from A.D. 962–1806. The empire was a confederation of independent territories controlled by noble families and cities that presumably gave allegiance to the Holy Roman emperor but frequently clashed with him. The emperor struggled continually with the **papacy** over the right to appoint bishops and control over Italy. The empire effectively ended when Napoleon was given the crown (1806).

HOMERIC Adjective used to evoke the **heroes, themes,** and other ideas in the **epics** attributed to Homer, the *Iliad* and the *Odyssey,* which date from around 750 B.C.

HORATIAN An adjective used to describe the poetry, poetic style, verse forms, and **critical** principles of the Roman poet Horace (65–8 B.C.).

HUBRIS, hubristic The Greek word for excessive, blinding pride or arrogance; usually the prelude to some catastrophe that educates someone about his or her human limitations ignored or obscured by arrogance. See **tragedy.**

HUE The attribute of a color that makes it red, green, and so on. There are six basic hues: red, orange, yellow, green, blue, and violet. White and black have no hue. See **value.**

HUGUENOTS French **Protestants** during the sixteenth and seventeenth centuries who followed **Calvinist** doctrines. When their right to religious freedom was revoked in 1685, many emigrated to England, the Netherlands, and Switzerland.

HUMANISM, humanistic, humanist Most simply, putting the emphasis on human beings as the center of all things and meaning, and expressing confidence in their worth, abilities, **rationalism**, accomplishments, nobility, and dignity, apart from the gods, religion, or the supernatural. There have been many times in **Western** history when humanism has arisen. The first time was in ancient Greece and Rome, which provided the models and inspiration for later humanist thought. In the **Renaissance,** a humanist was a student of Greek and Latin literature and culture. The humanism of the period also stressed human freedom, **reason** and intellectual ability, the capacity of people independently to acquire knowledge and be creative, as well as displaying an interest in the **natural** world as a realm of beauty, order, and knowledge rather than as a mere arena of corruption and sin. The term *humanism* is sometimes used disparagingly today, usually in the phrase *secular humanist,* to indicate an overemphasis on and exaltation of human beings at the expense of God's will.

HUNDRED YEARS WAR The struggle between the English and the French arising out of claims to the French throne and the attempt to control France on the part of English kings, from around 1330 to 1450. English gains were ultimately won back by the French under Joan of Arc.

HUNS A pastoral, nomadic people who invaded Europe from the east starting in the fourth century A.D. They attacked Italy under Attila (c. A.D. 406–453) but were eventually defeated by the Romans and their Visigothic allies. Later, the English in World Wars I and II called their German enemies Huns.

HUNTERS-GATHERERS People who do not practice agriculture but hunt game and gather whatever available vegetables, fruits, and nuts they can find. They do not stay in fixed settlements, and family units provide the basic social organization.

HYPOTHESIS A tentative assumption about the solution to a problem, which is subjected to testing in the light of evidence. See **theory, scientific method.**

IAMB, iambic See **meter.**

IAMBIC PENTAMETER See **meter.**

ICE AGE A period of time when glaciers covered northern Europe, ending around 10,000 years ago. See **Palaeolithic.**

ICON A pictorial representation, sometimes suggesting an idol or a **symbol** of something. In art and religious history, icons are small religious paintings used in devotions by Eastern Orthodox Christians.

ID See **Freudianism.**

IDEA, idealism Generally, an idea is any object of thought or **consciousness.** In **Platonic philosophy** the idea is the perfect **form,** the eternal, unchanging essence of a concept or thing that exists apart from any observer or material instance of the idea. Idealism is the philosophical view that what is truly real exists in our minds, that the only way we can get at the world is through our minds and their contents. In history, idealism approaches history in terms of ideas, which are the important agents of change and development.

IDEOLOGY, ideological Ideology most simply means a systematic set of **ideas,** values, and concepts that concerns human existence and society and that some critics think can be found in all

of a society's productions, from advertising to literature to music. More specifically, ideology refers to such a set that supports and justifies a particular group's political, social, and economic power and privilege. In this sense the ideology is not necessarily true but rather is an abstract and arbitrary rationalization for a group's exalted position. Hence, ideology suggests something unreal, false, or illusory, or even dishonest and duplicitous. See **politics, power.**

ILLUMINATED MANUSCRIPT A **medieval** book, like a Bible or psalter (the Psalms), copied by hand and decorated with intricate and elaborate designs, borders, and initials, and illustrated with brightly colored **scenes** linked to the subject matter of the text.

IMAGE, imagery In art an image is a contrived, usually **concrete,** and sensory representation of an idea, person, or thing; imagery refers to images and their use in a particular work, author, or **genre.** A red rose, for example, is an often used image of sexual love. There are traditional images, such as the rose, that artists have used over and over, and there are images individual artists create. Images, which include more specific figurative devices such as **metaphor** and **simile,** are the way literature, particularly poetry, can make its language vivid and striking, as well as render abstract ideas more accessible to the reader's imagination. For example, John Keats in "Ode to Melancholy" (1820) used the striking image of crushing a grape against one's palate to communicate the rather **abstract** point that pleasure must be aggressively and intensely enjoyed because it is always fleeting and, hence, its enjoyment is paradoxically dependent on the realization of its inevitable loss: "Though seen [i.e., Melancholy] of none save him whose strenuous tongue/Can burst Joy's grape against his palate fine." See **symbol.**

IMMACULATE CONCEPTION A doctrine of the Catholic Church that states the soul of the Virgin Mary was free from **original sin.**

IMPASTO Paint applied thickly.

IMPERIALISM, imperialist Most simply, the direct or indirect oppression, domination, and exploitation of weaker, less technologically and economically developed countries by more highly developed and powerful ones. In **Marxist** thought imperialism characterized **capitalist** societies that divide up the world into spheres of influence whose resources, labor, and markets they exploit. See **colonialism.**

IMPRESSIONISM An artistic movement of the late nineteenth century originating in France. Impressionist painters wanted to duplicate the transient, **subjective** visual and emotional impression that reality and people left on them, particularly in terms of the fleeting and shifting play of light and color rather than the **objective** reality itself. Their subject matter frequently involved the city and its frantic night life of cafes, streets, and entertainment.

IMPROVISATION To play music while extemporaneously deviating from the **melody.** See **jazz.**

INCARNATION In Christian **theology,** the doctrine that God took on human flesh and entered space and time in the form of Jesus Christ.

INDIVIDUALISM Used for any moral or political view whose starting point and most important value is the individual person rather than society. Humans have value simply by being human, not because they serve some other purpose or end. Excessive individualism, sometimes called radical individualism or atomic individualism, is seen as a byproduct of the modern age, whose scale, complexity, and breakdown of traditional communal life isolate people and make it harder for them to connect with others, leaving them self-obsessed and anxious.

INDO-EUROPEAN An adjective used to describe a family of languages that includes the Germanic, Italic, Celtic, Balto-Slavic,

and Indo-Iranian tongues. Sometimes used for an imagined nomadic people who spread over Europe, the Middle East, and India. See **Aryan.**

INDUCTIVE, induction A type of thinking that moves from particular phenomena to general conclusions. See **deductive, a posteriori, empirical.**

INDULGENCE In **medieval** Christianity, a remission of some part of the punishment for a sin, whether the punishment is due in this world or later in **Purgatory.** A huge traffic in indulgences was one of the corrupt practices of the medieval church that the **Reformation** attacked.

INDUSTRIAL REVOLUTION Historically, the transformation in the way goods were produced, first in England starting in the mideighteenth century, and made possible by innovations in **technology** and the way money was raised and invested. Important results include a more affluent way of life for more people; the rise of a middle class; greater urbanization as workers leave agriculture to labor in factories; a more complex and fast-paced life as more and more machines are invented; and problems such as pollution, class strife, slums, and poverty. See **capitalism, Marxism.**

IN MEDIAS RES Latin for "in the middle of things," where the story should start according to the Roman poet Horace's *Ars Poetica.* See *ars poetica.*

INQUISITION, the A court of the Catholic Church established in the early thirteenth century to hunt down and punish heretics—those people who believed doctrines considered by the Church to be wrong—with imprisonment, torture, and death. The Spanish Inquisition was established in 1479 to identify and punish witches and converted Jews and **Muslims** (followers of **Islam**) suspected of secretly practicing **Judaism** and Islam.

INTENTIONAL FALLACY To some literary critics, a mistake in interpretation that occurs when the work's meaning is limited to the meaning intended by the author. See **criticism.**

INTERNATIONAL BRIGADES See **Spanish Civil War.**

INTERPRETATION The act of and procedures for finding meaning or significance in art, literature, or history, and the coherent communication of that meaning to others, backed up by argument and evidence. Sometimes carries the implication that the meaning is a **subjective** one, peculiar to the individual doing the interpreting, as when we say, "That's just your interpretation." See **criticism.**

INTERTEXUALITY The notion that a **text,** or work of literature, is a literary construction of language and the system of literature, and refers not to reality but to other texts, language, and **genre** systems that make possible the individual work and its meaning. Sometimes the relationship between a text and other texts is seen as antagonistic or even hostile. Thus, analysis should focus on the appearance or influence of those other texts or systems. Often intertextuality is just a fancy word for **allusion.**

INTERVAL A musical term that refers to the distance between two **pitches.**

INVISIBLE HAND In the economic theory of Adam Smith (1723–1790), the invisible hand refers to the way the numerous free transactions, the prices, and the supply and demand of products in a market will be self-regulated and self-adjusted without any outside interference or despite the intentions of the people doing the buying and selling. Sometimes used for any order that is regulated or adjusted apart from people's plans or intentions. See **free market, capitalism.**

IONIAN PHILOSOPHERS The ancient Greek **pre-Socratic** philosophers from Ionia, the Greek cities on the coast and islands of modern Turkey. See **pre-Socratics.**

IRON AGE In **myth,** the morally corrupt present, marked by **technology** and complex urban life, contrasted with a lost, superior **Golden Age.** See **Golden Age.** As a term of **prehistory,** the Iron Age describes the period when iron is the principle material for tools and weapons, replacing bronze. In the ancient Mediterranean, it starts around 1200 B.C., and in a sense does not end because iron remains the most important metal until the modern period.

IRON CURTAIN A common name for the barrier once existing between the Soviet Union–dominated countries of Eastern Europe and the **democracies** of Western Europe. The Iron Curtain disappeared with the disintegration of the Soviet Union in 1990.

IRONY, ironic Irony refers to the simultaneous presence in a statement of two contrasting terms: the appearance and the reality, or the intention and the result, or the words and the intended meaning. An ironic statement has two meanings—the surface one and the submerged one that is really true and sometimes is the opposite of the surface meaning. When a literary character doesn't know his or her words have a true submerged meaning, this is dramatic irony. Oedipus in Sophocles's *Oedipus Turannos* (c. 430 B.C.), who doesn't know that he has killed his father Laius and married his mother Jocasta, repeatedly makes ironic statements, such as: "I will fight for him [Laius] as though for my own murdered father"; of course, Laius *is* his own murdered father, the further irony arising from the fact that Oedipus himself murdered him. A brilliant example of irony is Jonathan Swift's *A Modest Proposal* (1729), in which Swift condemns the neglect of poor Irish children by proposing the problem be solved by raising them for food. The irony is brutally simple: If we won't feed these children, let's eat them. Do not use *ironic* when you just mean **paradoxical.**

ISLAM, Islamic The **monotheistic** religion of Muslims, revealed to the Arab Mohammed (c. A.D. 570–632), who is the prophet of the god Allah. In the seventh and eighth centuries A.D. Islam spread by warfare throughout the Middle East, North Africa, and southern Spain. Its holy book is the **Koran.**

J

JACOBEAN An adjective that describes the times and culture of the English king James I (1566–1625), used particularly of the **drama,** which was characterized by lurid sexual intrigues and graphic violence.

JACOBIN, Jacobinism Extremist or **radical leftist** political thought, after a terrorist group active in France during its revolution (1789).

JAZZ A style of music developed by African American musicians in the early twentieth century, characterized by **improvisation** and **syncopated rhythms.**

JESUITS The Society of Jesus, founded by St. Ignatius of Loyola (1491–1556). They were concerned with the reformation of the Catholic Church, with fighting intellectually against **Protestantism,** missionary work, and education. See **Counter-Reformation.**

JUDAISM The **monotheistic** religion of the Jewish people, who worship Yahweh, with whom the Jews have a unique, exclusive relationship through the Covenant first established with Abraham.

JUNO Roman equivalent of **Hera;** wife of **Jupiter.**

JUNTA A committee or council created for political purposes or to run a government, usually after a revolutionary seizure of power.

JUPITER Roman king of the gods, equivalent of **Zeus.**

KEY In music, the system of seven **tones** based on a central **note** called the keynote or **tonic**; also the **tone** or **pitch** of a voice. See **major, minor, scale.**

KEYNESIAN ECONOMICS Economic theory developed by John Maynard Keynes (1883–1946). Contrary to **free market** economic theories, Keynes argued for government intervention in the economy in order to stimulate employment and control inflation.

KEYSTONE See **arch.**

KORAN The holy book of **Islam**, revealed by Allah to the prophet Mohammed c. A.D. 570–632. See **Islam.**

LAISSEZ-FAIRE French for "let do." Generally refers to the belief that the government should not interfere in people's lives, especially regarding economic activity. See **free market, capitalism.**

LANDSCAPE The particular **natural** environment in a work of literature. In art, a kind of painting that features natural **scenes.**

LAST JUDGMENT In Christian **theology**, the Second Coming of Christ, when the earth and time will be no more and everybody will be judged, after which the saved go to heaven and the damned go to hell.

LAY A short **lyric** or **narrative** poem.

LEAGUE OF NATIONS An organization created in 1919 after **World War I** whose goal was to promote international cooperation. The United States Congress never ratified the treaty, and the league was unsuccessful at mitigating the various crises that eventually erupted into **World War II.**

LEFT, leftist A political view that advocates dramatic, sometimes revolutionary, change in economics, government, and society in order ostensibly (1) to increase the freedom and equality of the greatest number of people, particularly the impoverished or dispossessed; and (2) to distribute economic resources more equitably. Also, the advocacy of greater and more extensive governmental power in order to achieve these goals. See **conservative, liberal, radical, socialism.**

LEITMOTIF In opera, a musical **theme** that represents a **character,** place, or an **idea,** usually repeated with variations that reflect changes in the story. Sometimes used in literature to indicate a dominant repeated theme. See **motif.**

LEPANTO, Battle of A sea battle in Greece between the **Ottomans** and an allied European force fought October 7, 1571. It was the last sea battle fought with **galleys** and the first European victory over the Turks.

LEVANT, Levantine The countries that border the eastern Mediterranean: Egypt, Palestine (modern Israel), Lebanon, Syria, and Turkey.

LIBERAL, liberalism A political view that gives primary importance (1) to the political and civic rights of individuals, and (2) to the freedom of individuals to pursue their goals and happiness with the least possible degree of external restraint, particularly that of government or society. In popular usage, liberal sometimes is used to describe those who are willing to use government

power to advance social justice or equality. See **natural rights, conservative, individualism.**

LIBIDO Freud's term for psychic and emotional energy whose ultimate origins lie in some primal urge, usually sexual. See **Freudianism.**

LIBRETTO The written text of an **opera** or **oratorio.**

LINE In poetry or **drama,** a structural unit consisting of a certain number of syllables. In art, the mark made by a moving brush or pencil that creates shape. See **meter.**

LINEAR PERSPECTIVE See **perspective.** See Figure 4.

LITERAL This word used of literature refers to the surface or obvious sense, apart from any **symbolic** or **metaphoric** meanings. Literary analysis is seldom concerned with the literal meaning, as this is usually apparent—though you must understand and get right the literal meaning before you can move on to symbolic interpretations.

LITERARY CRITICISM See **criticism.**

LITERARY TRADITION A way of designating all the works of literature that are read beyond their own time, and the various literary techniques, **themes,** devices, **imagery, characters,** and so on that occur in those works. This group of works is not rigidly defined and changes through time as some works fade from favor and fashion and others are added. See **canon.**

LITURGICAL From *liturgy,* a rite or ceremonious order of words and action used in public worship.

LOGIC The science of argument, including the principles of reasoning and the standards for demonstrating that propositions are valid.

LOGICAL POSITIVISM A twentieth-century movement that believes a statement is meaningful if it can be verified through analysis of its grammar and words, or through **empirical** observation and experiment. Do not confuse with **positivism.**

LOGOCENTRISM An idea that derives from **deconstruction.** Logocentrism describes the illusion that there exists a separate, definite, transcendent meaning that is present in language, apart from and prior to the word system, which, according to deconstruction, actually makes possible a word's wide range of possible and shifting suggestions of meanings. More widely, logocentrism can refer to the privileging of reason and its procedures for establishing truth as the foundation of human identity to the exclusion of everything else. To those who believe it, the term *logocentrism* carries a negative force because it attempts to hide what is taken to be the exclusionary, arbitrary system of **Western** thought, language, and philosophy—a system whose origins lie in the historically determined **political** conditions that give one group power over another that is excluded—and to locate this system in an ahistorical, "**natural**" order of things that attempts to put it (and the power relations it rationalizes) beyond change. See **poststructuralism, deconstruction.**

LOGOS A Greek word that means "word" or "rational account." In Christian **theology,** Christ is the logos, God's creative order as communicated to people through the gospel.

LUDDITES, Luddism An early nineteenth-century English protest movement that destroyed machinery believed to be taking away jobs. Now used of any view that is against **technology.**

LYCEUM, the Another name for the philosophical school founded by Aristotle (384–322 B.C.).

LYRIC Lyric originally described poetry that was sung to the accompaniment of a stringed instrument such as a lyre, which is

why we use the word today to refer to the words of a song. Later it came to denote a brief poem that is concerned with the **subjective,** emotional experience of the speaker (the narrator of the poem who may or not be the same person as the poet, whether or not the poem uses the pronoun *I* or even the poet's real name). A wide variety of poems can be generally designated as lyric—most of the poetry people read and write today is technically lyric poetry. In music, the lyrics are the words to a song.

MACHIAVELLIAN From Italian thinker Niccolò Machiavelli (1469–1527). Used to describe a **political** ethic that does not consider moral improvement to be a statesman's goal, but rather **power** and stability. More loosely used for politicians or leaders who believe the ends justify the means, and that any act no matter how terrible, immoral, or dishonest is acceptable if it maintains the leader's power.

MACROCOSM, microcosm The "big world" and the "little world": the world of **nature** or society (macrocosm) and the world of the human or the individual (microcosm). The use of these terms usually implies that an **analogy** can be made between the macrocosm and the microcosm: that society, for example, is structured or organized in ways similar to an individual.

MADONNA The Virgin Mary. A frequent subject in **medieval** and **Renaissance** art. A painting that shows Mary with the infant Jesus is called a "Madonna and Child" or "Virgin and Child." See **Pietà, annunciation.**

MAENAD See **bacchante.**

MAGICAL REALISM A literary **style** in Latin American writing that combines **realistic** events and characters with fantastic or unreal ones.

MAGNA CARTA The document that English barons forced King John to sign at Runnymede on June 15, 1215. Its clauses set out the limitations of kingly power and the privileges and rights of boroughs and the Church.

MAJOR The name for one of two particular seven-**tone scales** or **keys,** the other being the **minor.** A major or minor key corresponds with the major or minor scale that starts on a particular **note.**

MANICHAEAN, Manichaeism Manichaeism was a religion started in the third century A.D. by the Persian Mani (A.D. 216–277). Manichaeism fused Christian, **gnostic,** and Persian religious elements (from **Zoroastrianism**). It starkly divided the world between good and evil, light and dark, ignorance and wisdom, matter and spirit. Used generally for any view that contains two opposing elements, particularly if those elements are associated with good and evil.

MANIFEST DESTINY A political idea in the nineteenth century in the United States that advocated territorial expansion westward to the Pacific Ocean as the peculiar destiny of the United States, no matter who was already in possession of those territories.

MANNERISM, mannerist As a term of art history, mannerism describes the period between the **Renaissance** and the **Baroque** periods (sixteenth century). As a **style,** mannerist painting and sculpture featured obscure subjects, elongated bodies and strange poses, distorted **perspective** and **scale,** harsh or unreal colors, and unbalanced **composition.** More generally used of any art that is affected, exaggerated, overly or lushly ornamental, or excessively contrived and complicated.

MARATHON Site of the victory by the Athenians and their Plataean allies in 490 B.C. over the invading Persians, who outnumbered the Greeks three to one. The modern race called a marathon is twenty-six miles because that is the distance from Marathon to Athens. Legend has it that a messenger ran the whole way to Athens with the news of the victory and then dropped dead. The prestige and influence of Athens in the fifth century B.C. were fueled by this victory that made the Athenians the "saviors of Greece."

MARS Roman god of war, equivalent of the Greek **Ares.**

MARTYR, martyrdom A martyr is a person who chooses to die for his or her religious or political beliefs; used more particularly of Christians killed by the Romans.

MARXIST, Marxism Political, economic, and social ideas derived from the work of Karl Marx (1818–1883). The basic components are the centralized state control of economic activity and the abolition of private property; a **materialist** view of human life, history, and value; a preeminence given to economic class (owners and workers) over other social relations; the view that class struggle is inevitable and revolution a necessary stage in eradicating injustice and inequality; and the belief that **culture,** society, values, and so on are **epiphenomena** of how a society is organized economically, particularly its means of production. See **communism, capitalism, socialism, proletariat.**

MASQUE A form of aristocratic entertainment popular in the sixteenth and seventeenth centuries. The masque combined dancing, singing, poetry, and music and featured elaborate scenery and costumes with mechanical special effects and fantastic and mythological subject matter.

MASS MEDIA All the sources of information or entertainment that are produced in high volume and delivered to large numbers of people, such as newspapers, magazines, television, radio, movies, and advertising.

MATERIALISM, materialistic Refers to beliefs or **theories** that assert physical matter is the only basis for reality, and that reduce all morality, **ethics,** and values to a physical origin, whether that be **nature,** economic structures, or social organization. More generally, used usually negatively to describe an excessive concern with material possessions.

MEAN, the In Aristotle's **ethical** belief, a **virtue** is defined as residing somewhere between two opposite extremes. Thus, courage would be the mean between cowardice and foolhardiness. Where that mean lay could not be determined just intellectually but by experience as well. Sometimes called the "golden mean," from a poem by the Roman poet Horace (*Odes* 2.10, *auream mediocritatem*).

MEASURE The unit into which written music is divided.

MEDICIS A powerful family of bankers in fifteenth-century Florence, one of them becoming Pope (Leo X). The Medicis were the patrons of many **Renaissance** artists such as Michelangelo.

MEDIEVAL See **Middle Ages.**

MEDIEVAL ROMANCE See **romance.**

MEDIUM, media The physical material—oils, marble, wood, metal, and so on—in which an artist works. *Media* is sometimes used for **mass media.**

MELODY, melodic A series of musical **tones** in which **rhythm** and **pitch** are combined into a unified whole.

MEMENTO MORI Latin for "remember you must die." An **image** in a painting or on jewelry, usually of a skull, intended to remind the viewer of his or her mortality and the vanity of earthly things.

MENTALITIES (in French **mentalités)** A term created by a school of French historians in the 1960s. A mentality is the specific, identifying worldview of a particular **culture** or society: the collective, unique way that it unconsciously organizes, categorizes, and assigns meaning and value to experience and actions.

MERCANTILISM An economic policy of the seventeenth century that used governmental power to increase a nation's wealth and influence by exploiting natural resources, thereby increasing exports and limiting imports; to accumulate gold and silver; and to maintain a favorable balance of trade by imposing tariffs on imports.

MERCURY Roman equivalent of **Hermes.** Also associated by the Romans with trade.

MESOLITHIC The Middle Stone Age, the period between the **Palaeolithic** and **Neolithic,** from 10,000–8000 B.C., when most peoples were **hunters and gatherers** and the glaciers began to retreat. See **Stone Age.**

MESOPOTAMIA A term that describes the area in the Middle East between the Tigris and Euphrates Rivers that was the site of early civilizations such as the **Sumerian.**

METAPHOR An implied comparison between two objects in which one is given the characteristics or qualities of the other, which are at some level similar. Very often a metaphor is a way of using **concrete** imagery to make more vivid and familiar an **abstract** idea that may be obscure or less well known, or to specify a peculiar emotion that is vague. For example, when Hamlet says, "O that this too too sullied flesh would melt,/Thaw, and resolve itself into a dew" (I.ii.129–30), he compares the body to snow or ice not because they are physically similar but because he is feeling emotionally lifeless—"cold"—since his father's death.

Hence, because he is emotionally like ice, he wishes that he shared ice's ability to melt and dissolve, that is, to "die" painlessly. (Notice, too, the **pun** in "a dew," which sounds like the French word for "goodbye," *adieu*.) Metaphor is one of literature's most important devices for communicating emotions or ideas that if put into **literal** language would be flat or boring or take too many words—metaphor concentrates meaning into a brief verbal space, suggesting numerous (but not limitless) complexities, implications, and possibilities for interpretation as you think more deeply about the two terms being compared.

METAPHYSICAL POETRY English poetry of the early seventeenth century characterized by intellectual complexity or difficulty; ingenious, striking, and contrived **metaphors** and other figures of speech; obscurity; and **irony** and **paradox**. John Donne (1572–1631) is perhaps the most famous metaphysical poet.

METAPHYSICS That part of **philosophy** concerned with questions of the fundamental nature of reality—especially **being** or existence (**ontology**) but also the problems associated with the conditions and possibilities and problems of knowing reality (**epistemology**).

METER, metrical The formal rhythmic patterns of poetry. In English these patterns are established by the alternation of stressed and unstressed syllables, with words of one syllable able to be either stressed or unstressed. These patterns can be loose, with a certain number of stresses per line in no traditional pattern, called **free verse,** or more rigid, with a precise pattern deriving from ancient Greek and Latin poetry. The basic unit is the **foot,** which comes in the following patterns (given their traditional ancient Greek names; + means unstressed syllable, − stressed): iamb [iambic], + −; trochee [trochaic] − +; anapest [anapestic] + + −; dactyl [dactylic] − + +; spondee [spondaic] − −. There are others, but these are the major ones. Each kind of foot has a different "feel" to it. Iambic is conversational: We TEND to SPEAK in

I-ambs; spondees are slow or serious or emphatic; anapests and dactyls make for a speedier, more exciting line (think of an anapestic poem such as "The Night Before Christmas" or "The Midnight Ride of Paul Revere"). The number of feet determines the name of the line: Monometer has one foot; dimeter, two; trimeter, three; tetrameter, four; pentameter, five; hexameter, six. The metrical pattern is identified by naming the kind of foot and line the verse is written in: A line with six feet of dactyls is called **dactylic hexameter;** five feet of iambs (ten syllables total) make an **iambic pentameter** line. However, few good English poems are written in strict accord with these patterns, most poets using frequent variation to avoid a mechanical, sing-song rhythm. Very frequently, for example, a line of Shakespeare written in verse and designated iambic pentameter (also called **blank verse** when un-rhymed) will have other kinds of feet in it and more than ten syllables. Consider the following famous line from *Hamlet:* "To be, or not to be—that is the question" (III.i.56). If you read this line as normal speech and with the emphasis on the sense, rather than according to the unstressed-stressed pattern of iambic pentameter, it probably will sound: "To BE, or NOT to be—THAT is the QUEStion." Notice the line has eleven syllables, and the stress pattern isn't regularly iambic. In the best poems, meter is not a rigid pattern shackling the words but rather a more flexible structure that the poet varies for any number of effects. Ideally, the meter should reinforce the sense with its rhythm. Listen to how the dactyls and anapests in the second line of this famous couplet from Andrew Marvell's "To His Coy Mistress" (1681) reinforce the sense of urgency and time's irresistible persistence that the speaker invokes to convince his girlfriend to go to bed with him: "But at my back I always hear/Time's wingéd chariot hurrying near." The second half of the line is "fast," just as Time is.

METHOD, methodology Research techniques, rules, and systematic procedures or processes of inquiry particular to a discipline and used to arrive at conclusions. Methodology is important for standardizing the search for truth and making it systematic

rather than haphazard. However, some people question whether any methodology can be neutral and discover truth without distorting the evidence to serve the methodology's particular procedures or processes.

METONYMY, metonym, metonymic A figure of speech in which a word associated with a thing is used for the thing itself. *Crown* is a metonym when used to describe a king, or *bench* when used to describe a judge. Edward George Bulwer-Lytton's famous phrase "The pen is mightier than the sword" contains two metonyms: *pen* referring to written ideas, *sword* referring to war. See **symbol, synechdoche.**

MIDDLE AGES, medieval The period in European history between the **Roman Empire** and the **Renaissance** (roughly A.D. 500–1500). Sometimes divided into the **Dark Ages** and the High Middle Ages (twelfth and thirteenth centuries).

MIMESIS, mimetic From the Greek word for "imitation." **Criticism** uses this term to refer to a theory in which art at some level imitates life and **nature.** This theory principally derives from the Greek philosopher Aristotle's work of criticism, *The Poetics* (fourth century B.C.). See **The Poetics, realism.**

MINERVA Roman equivalent of **Athena.**

MINIMALISM, minimalist Art that uses the least amount of ornamentation and **symbolism** and that features extremely simple **forms** and elements. In literature, refers to a **style** that uses spare, simple, and direct language.

MINOR See **major.**

MINOTAUR Creature with the body of a man and the head of a bull. Kept locked away in the labyrinth built by the architect Daedalus. Ultimately killed by the Greek **hero** Theseus.

MINUET A dance in three-quarter time. **Baroque** composers incorporated minuets into their **suites** and **sonatas,** and it eventually became part of the **sonata** form. Sometimes minuets are written as independent pieces.

MITHRAISM A religion that flourished about the time of early Christianity and promised immortality to its followers, after the Persian god Mithras, god of wisdom and light.

MIXED MEDIA Art that uses two or more **media.**

MOCK EPIC A kind of poetic **satire** that combines an elevated **style** and **diction** characteristic of **epics** with a trivial subject matter, though not necessarily an unimportant **theme.** Alexander Pope's *The Rape of the Lock* (1712), about a young lady who loses a lock of her hair, is a good example from English literature.

MODELING, to model In painting, the creation of three-dimensional **forms** by manipulating colors and shadows to suggest the different intensities of light on a body.

MODERN ART Artistic movement of the late nineteenth and the twentieth centuries that rejects the traditional ways of doing art (such as **realism** or **representation**) in favor of new ones that more accurately reflect the modern world and its experiences. See **modernism, modernization, postmodernism.**

MODERN DANCE A style of dramatic dancing that is less formal than **ballet** and that allows more **improvisation** and expressiveness.

MODERNISM, modernist When used in literary history, modernism covers the period from **World War I** to the 1960s. The general qualities of literary modernism include a strong sense of self-consciously breaking with **literary tradition** in terms of technique, **style,** or subject matter (see **avant-garde**); a sense of

crisis in **Western** history, with an aura of imminent dissolution due to the failure of political, social, and economic institutions; a dissatisfaction with **capitalism** and the vulgar materialism and mass culture it promotes; the idea of alienation, as modern science describes a cosmos stripped of God, **providential** order, and human significance; a greater interest in the individual and his or her **psychology** and inner life; and a high value (though laced with despair at its usefulness) placed on the artistic imagination and its creations, both perceived as superior to a decaying Western culture and its soul-killing science and technology. See **postmodernism.**

MODERNIZATION, modernity The historical process of social and economic changes that started two hundred years ago, including secularization, industrialization, urbanization, rationalization of **political** and economic life, a rejection of tradition, and the greater involvement of ordinary people in public life. Modernity is the end result of those processes, the world we live in today. See **postmodernism.**

MODULATION Changing from one **key** to another in a piece of music.

MONARCHY, monarchical, monarchist Rule by a hereditary king who holds power for life. This power can be absolute or more limited. See **absolutism.**

MONASTICISM, monastic, monastery Refers to the organized life of monks in monasteries, dedicated to religous devotion. The key rules for monastic life—frequently ignored or abused—were poverty, stability (staying put), chastity, and obedience. Monasteries in the **Middle Ages** were important institutions for keeping alive and spreading learning through the copying, revising, and illustrating of manuscripts. Monasteries were also crucial for the spread of Christianity in the early medieval period.

MONOLOGUE A kind of literature or part of a literary work in which only one person speaks. See **soliloquy.**

MONOTHEISM, monotheistic The belief in one all-powerful (omnipotent), all-knowing (omniscient), present everywhere (omnipresent) God, usually attended with the disbelief in the reality of any other gods. This God demands righteousness—a certain kind of moral and ethical life, exclusive worship, and strict obedience. Christianity, **Judaism,** and **Islam** are all monotheistic religions. See **polytheism.**

MOOR A European term used to describe the followers of **Islam** from North Africa who conquered Spain.

MORALITY PLAY A kind of **drama** popular in the **Middle Ages** that presented a Christian **allegory** about salvation, particularly as this issue is occasioned by the imminence of death.

MOSAIC A decoration on walls and floors in which **scenes** or patterns are created out of small stones (*tesserae*) of different colors. As an adjective, *Mosaic* refers to the Hebrew leader Moses, particularly the laws (the Mosaic law) such as the Ten Commandments Moses transmits from God to the Hebrew people while they are traveling from Egypt to Canaan.

MOTIF A recurring **theme, idea,** or other element in art and music. Also in painting a design or color. More specifically, an art term that refers to the real-life **landscape** in a landscape painting. See **leitmotif.**

MOTIVE In literature, something (such as a need or desire) that makes a **character** act. In music, a **melodic** or **rhythmic** unit in a **composition.**

MOVEMENT A major self-contained unit in a large musical **composition.** See **symphony.**

MURAL A large painting designed for a wall, either painted directly on the wall or on something else attached to the wall.

MUSE, Muses Nine ancient Greek goddesses believed to inspire poets, artists, and thinkers. Poets would sometimes invoke the Muse at the beginning of their poems. They were Calliope (**epic**), Clio (history), Erato (love poetry), Euterpe (music), Melpomene (**tragedy**), Polyhymnia (religious songs), Terpsichore (dancing), Thalia (**comedy**), and Urania (astronomy). Later the Muse became a traditional **symbol** of the poet's inspiration and imaginative power.

MUSLIM A follower of **Islam.**

MYCENEAN Adjective describing the society, art, and literature that dominated ancient Greece and parts of the eastern Mediterranean from the sixteenth to the twelfth centuries B.C. The **Homeric epics** contain material and details that ultimately originated in the Mycenean period.

MYSTERY PLAY, miracle play Medieval drama focusing on the Christian **theological** issues of the Creation, **Fall,** and **Redemption.** A miracle play treated the life and martyrdom of Christian saints.

MYTH, mythology, mythological In literature and art, a traditional story with supernatural elements, most often explaining the origins of a **natural** phenomenon, person or type of person, society, social or cultural practice, religious ritual, or name of something; or a story that explains some aspect of the human predicament, such as the necessity of death, or social arrangements, such as why one group has power and another does not, or **psychological** conditions. Myth now implies a story that is not literally true, so to a religious believer, for example, the stories in holy writings will not be seen as myths. Thus, the stories from the Bible will be myths to nonbelievers but not to Christians. Western art, music, and literature have been enriched with the myths

of many peoples, including the Hebrews, but especially with those of the ancient Greeks and Romans, which provide a marvelous variety of characters, stories, and **images** that can illuminate and give depth to the writer's own story or idea. For example, in James Joyce's *Ulysses,* the aspiring artist Stephen Daedalus (whose last name refers to the mythic Greek creator and designer Daedalus, a mythic representation of the artist and his fate) mentally describes his feelings about his inability to leave his father's limiting world of Dublin by constant references to the Greek myth of Icarus, Daedalus's son who along with his father escaped imprisonment by flying away on wings his father created out of wax and feathers. However, disobeying his father's command, Icarus in his intoxication with flying free goes too close to the sun, which melts the wax and destroys his wings. Icarus falls into the sea and dies. The myth and its details help to develop economically for the reader the ambivalence, nuances, and complexities of Stephen's psychological predicament. See **archetype.**

NAPOLEONIC WARS The wars between the French under Napoleon (1769–1821) and the European powers and England from 1796–1815.

NARCISSUS In Greek myth, a beautiful youth who falls in love with his own reflection and slowly pines away with unrequited love until he becomes the flower of the same name.

NARRATOR, narrative Narrative refers to art that represents or literature that tells a story; also another term for "story." The narrator in a story is the one who tells it. A first-person narrator is a **character** in the story who uses the pronoun *I;* a third-person

narrator is not a character in the story; an omniscient narrator is a God-like third-person narrator who can describe people's thoughts and who knows more than any one person could in reality. Sometimes a third-person narrator will reflect the personality or **point of view** of one of the characters: Jane Austen's *Pride and Prejudice* (1813), in which the third-person narrator frequently sympathizes with Elizabeth Bennet's point of view, is a good example.

NARRATIVE HISTORY A way of describing the historical past and historical change by using a story form.

NARTHEX The entrance hall to a church.

NATIONALISM A political doctrine that believes national identity—the common language, history, values, religion, social practices, customs, **culture,** and beliefs that bind a people and identify them as living a particular way of life—is preeminent and should be recognized and expressed politically. Also, the belief that a **nation-state** has rights and should protect its independence and autonomy and promote its own interests before that of any other nation. Nationalism puts the loyalty of the individual and the group to the nation ahead of all other obligations.

NATION-STATE A political organization centered on a culturally and ethnically homogeneous people. See **nationalism.**

NATURALISM Generally, a belief that art should represent the world as it actually is, without distortion or fidelity to the **conventions** of tradition. As a type of philosophy, naturalism limits inquiry to the unified world of nature without allowing in the supernatural or spiritual.

In literature, a type of **novel** that tries **objective**ly to describe its **characters** and their environment and heredity, particularly in order to show how the latter two shape the former. Influenced by the scientific advances of the nineteenth century, particularly the work

of Darwin, the naturalist novelists of the late nineteenth and early twentieth centuries considered themselves to be objective "scientists" who describe people and society through the medium of **fictions** that are representative of the truths of the laws of nature that ultimately determine human **psychology**, life, and action. As such, they did not consider any subject matter, no matter how sordid, unpleasant, or indecorous, unworthy of description or exploration. The best-known novelist of naturalism was Emile Zola, who in twenty novels known as the *Rougon-Macquart* cycle (1871–1893) described the whole of French society from rich grandees to peasants to prostitutes. In America, Theodore Dreiser's *An American Tragedy* (1925) and *Sister Carrie* (1900) display many of naturalism's assumptions. See **realism, social Darwinism.**

NATURAL LAW Common moral standards that are believed to exist naturally and objectively or to have been created by God, apart from any particular historical society or political order; that serve justice and right and, hence, are superior to any local society's customs and laws; and that ought to form the basis of and provide the goals for any legitimate political and legal authority.

NATURAL RIGHTS **Rights** that belong to people by nature or because of **natural law** and that are part of their identity as human beings. Hence, they cannot be taken away (they are inalienable) or modified by particular governments or laws. The U.S. Declaration of Independence lists "life, liberty, and the pursuit of happiness" as natural "inalienable rights."

NATURAL SELECTION See **Darwinism, evolution.**

NATURE, natural Most simply, nature is the environment and the creatures in it, everything not created by human beings. The term carries a positive or negative charge depending on the time. In the premodern world, when humans had to struggle for survival in a harsh world filled with disease, predators, famines, and so on, nature was perceived as potentially destructive and dangerous, in need of control and organization in order to provide

humans with what they needed to survive. Nature contrasted with **culture,** the human-created laws, **technologies,** institutions, customs, and so on, that created order out of nature and harnessed its creative energies ("culture versus nature"). After the rise of science and the development of technologies that controlled nature and eliminated for many humans its destructiveness, nature starts to become idealized as a superior realm to the artificial, complex cities in which we live. *Natural* then has a very positive charge, used to describe whatever is simple, authentic, and true to our human identity when it is uncorrupted by artificial civilization. See **Romanticism.**

Another dimension of the term *nature* concerns an inherent order and beneficent design believed to exist in both the world and humans and their institutions, one created by a divine power or God according to his benign intentions for humanity. Living naturally then would be living according to this order and fitting in with its intentions. Unnatural behavior would then be actions and choices that violate this order and corrupt its purpose. See **providence.**

NAVE The rectangular main room of a church, extending from the **narthex** to the **apse** or **choir.** The nave will frequently be flanked by **side aisles.** See Figure 1.

NAZISM, Nazi NAZI was the German acronym from the name of the National Socialist German Workers Party, a German political movement created in 1919 and destroyed in **World War II.** It was a **nationalist** and **fascist** political philosophy, with a **racist** belief in the purity of a mythic **Aryan** race and the need to eliminate other races and ethnic groups considered less human. Nazism became the instrument of Adolf Hitler's (1889–1945) rise to power in Germany and attempt to conquer Europe. See **holocaust, final solution, fascism, nationalism.**

NEOCLASSICISM Neoclassicism refers to a period in European cultural history dating from the midseventeenth to the

mideighteenth centuries, and to the principles of **classicism** uniting neoclassic writers, architects, and artists; a view of art as a traditional craft best practiced by rationally learning and imitating the literary and artistic rules, techniques, and procedures derived from ancient literature and art, particularly Roman. Neoclassicist poets were concerned not with the individual or private feeling but with man as a social animal. Classicism and neoclassicism are both frequently contrasted with **romanticism.** Also an English literary movement spanning the midseventeenth to mideighteenth centuries, including writers such as John Dryden, Jonathan Swift, Alexander Pope, and Samuel Johnson. See **classicism.**

NEOLITHIC The period of history also called New Stone Age (c. 8000–2000 B.C.), characterized by pottery, agriculture, and early forms of writing. See **Stone Age.**

NEOPLATONISM, neoplatonist A version of **Platonic** philosophy that developed in the **Roman Empire** from the third to the fifth centuries A.D., founded by Plotinus (A.D. 204–270) and further developed by Iamblichus (A.D. c. 250–326) and Proclus (A.D. 410–485). Generally it posits a single, nonmaterial, absolutely good, self-created, creative, **rational,** divine source of **being** that extends itself into lower levels, each subsequent level being farther from, more material than, and, hence, a weaker expression of the pure source to which it longs to return. Neoplatonism's influence extended into the **Renaissance.**

NEPTUNE Roman equivalent of **Poseidon.**

NEW CRITICS A group of American critics active in the midtwentieth century, including John Crowe Ransom, Allen Tate, R. P. Blackmur, Kenneth Burke, Cleanth Brooks, and Robert Penn Warren. Their principles (see **criticism**) were popularized through the textbook *Understanding Poetry* (1938) by Cleanth Brooks and Robert Penn Warren.

NEW DEAL, the As a noun, refers to the policies and social programs, such as the Social Security Administration, initiated from 1933 to 1938 by U.S. President Franklin D. Roosevelt (1882–1945) to save the economy damaged by the **Great Depression** and ease the suffering of its effects. Sometimes used as an adjective to describe government programs that aim to solve some social or economic problem.

NEW HISTORICISTS See **historicism.**

NEW SCIENCE, the An **empirical** and **inductive** approach to discovering rationally coherent knowledge about the world depending on observation and experiment, in contrast to accepting without question whatever traditional authorities had said, first formulated in the writings of Francis Bacon. See **Baconian, empirical, induction, scientific revolution.**

NEWTONIAN Adjective that describes or evokes the scientific discoveries of Isaac Newton (1642–1727), including calculus, the laws of motion, and the law of gravity.

NEW WORLD, the A term used to describe the Americas after Europeans discovered them.

NIETZSCHEAN Adjective used to describe ideas derived from or evoking the **philosophy** of Friedrich Nietzsche (1844–1900). Used generally to describe views that reject God and religion as the source of human value and propose instead that people create their own values "beyond good and evil." Such people would be the "supermen," superior people who have discarded their dependence on traditional, otherworldly illusions to give life meaning.

NIHILISM, nihilistic From the Latin word for "nothing." The view that no legitimate basis or justification for morality or **ethics** exists. The nihilist believes in nothing—except, of course, nihilism, which is an incoherent position.

NIKE Greek goddess of victory, depicted with wings.

NOBLE SAVAGE A term first used by the English poet John Dryden (1631–1700). A **myth** as old as civilization itself, the noble savage embodies those ideals and simpler, more **natural** ways of life presumably superior to and more just than those of complex, sophisticated urban societies. This myth is frequently projected onto less culturally advanced societies, as the Europeans did when they encountered the natives of the **New World**. See **primitivism, Golden Age, romanticism.**

NOCTURNE Piece of piano music intended to be played at night and often gloomy or melancholy.

NONCOMFORMIST A **protestant** who does not recognize the discipline and rites of the **Anglican** church. See **Puritans.** Today it is used more generally of someone who rejects mainstream values and ideals.

NONFICTION A type of **prose** that is supposed to be factually true and/or concerned with real people. Types of nonfiction include biography, autobiography, **essays,** scholarly writing, and journalism.

NORMANS The Scandinavians who settled in northern France (Normandy) and conquered England in A.D. 1066. Later Normans briefly controlled much of Europe, creating an empire in Sicily. Sometimes Norman is used to describe a style of architecture that arose in Normandy. See **Romanesque.**

NORSEMEN Another name for the Scandinavians. See **Vikings.**

NOTE In music, the symbol for a specific **pitch**. See **pitch.**

NOVEL A literary **genre** that tells a story in **prose**. The variety of such stories—including their length, plots, characters, and literary **styles**—is immense, engendering a never-ending expansion

of novel types: detective novels, historical novels, epistolary novels (whose story is told completely in letters), science fiction novels, and so on. However, the most enduring novels in English written during the last two hundred years have tended to be characterized by **realism**—the attempt to duplicate a social and **psychological** reality the reader perhaps could encounter outside his or her door. Thus, the novel contrasts with **romance,** which typically has elements of the fantastic, supernatural, or melodramatic in its **plots** and **characters**, the latter tending to be flat and stereotypical. The novel of social and psychological realism, on the other hand, presents characters who have personalities, values, morals, behaviors, and motivations typical of the sort of people actually living (or imagined to have lived) during the time in which the novel is set. And these characters are in turn set in recognizable or at least believably described and detailed historical and social contexts that influence (and are influenced by) them and their actions. Although all good novelists focus on both character and setting—and despite individual critics' preferences for one over the other—different novelists have emphasized to differing degrees these two components of character and setting, some concentrating on their characters' psychological development, others on the surrounding social, historical, economic, and cultural forces. The American Henry James is an example of the former, and Charles Dickens is an example of the latter. This definition, however, should not obscure the wondrous variety of stories that novels have told over the years, and the endless experimentation with the genre that has occurred over its history. As Henry James said, the only obligation a novel has is to be interesting. See **realism, romance.**

NYMPH In Greek and Roman mythology, minor female goddesses associated with **nature,** especially trees, groves, caves, rocks, and so on. They are frequently shown as sexually aggressive and constantly are pursued by **satyrs.**

OBJECTIVE Used to describe facts, events, or conditions whose truth does not depend on any person's feelings, judgments, interpretations, prejudices, and so on. See **subjective.**

OCTAVE The **interval** between one **note** and the next of the same **pitch;** an eight-note interval. In poetry, an eight-line section of a poem. See **sonnet.**

ODE A type of **lyric** poem devoted to a single theme and characterized by complicated **metric** and **rhyming** patterns. Odes tend to be somewhat elevated and serious in tone, their **themes** tending to the philosophical or political. John Keats's six brilliant odes, *On a Grecian Urn, To a Nightingale, To Autumn, On Melancholy, On Indolence,* and *To Psyche* (1819) best represent in English this type of poem in its **philosophical** and meditative mode.

ODYSSEUS The crafty and much-enduring hero of Homer's *Odyssey* (c. 700 B.C.), who wanders ten years before finally returning to his home in Ithaca and reclaiming his kingdom and wife.

OEDIPUS COMPLEX Sigmund Freud's term for how the personalities of children (especially boys) develop, from the ancient Greek **myth** of Oedipus, who murdered his father and married his mother. Freud postulated that the infant male's first object of sexual desire is the mother; hence, the boy becomes the father's rival. The child, however, is terrified by the more powerful father and his threat of castration and so directs that sexual energy elsewhere, internalizing the father's threatening authority as the **superego.** This theory has very

few adherents anymore but is significant in much of literature and art influenced by Freud. See **Freudianism.**

OLD WORLD After the European discovery of the Americas, a term used to describe Europe, its culture, and its institutions.

OLIGARCHY, oligarchical Rule by the few, whether the elite is defined by merit, property ownership, or wealth.

OLYMPUS, Olympians Olympus, the highest mountain in Greece (7965 ft) in myth is the home of the twelve gods called Olympians: **Zeus, Hera, Apollo, Artemis, Hephaistus, Athena, Ares, Hermes, Poseidon, Aphrodite, Dionysus,** and **Demeter.**

ONOMATOPOEIA Words that imitate sounds such as *crack* or *pop.* In poetry, it is a device for having the sound of words reinforce the sense. The repeated *u*'s and *m*'s of Keats's line from *Ode to a Nightingale*—"the murmurous haunts of flies on summer eves"—suggest the lazy hum of flies.

ONTOLOGY, ontological The science of **being,** including topics such as the nature of existence and the structure of reality.

OPERA A kind of musical production invented in Italy in the early seventeenth century, opera is basically a **drama** set to music, with costumes, lighting, **scenery,** and so on.

OPUS, op. Latin for "work." The term used to identify a composer's **composition** with a number indicating the order of the work's publication.

ORAL POETRY Poems composed and performed orally by illiterate or semiliterate peoples. **Homeric epic** is believed to have originated in oral poetry.

ORATORIO A large musical work written for soloists, **choruses,** and an **orchestra,** and featuring religious subjects.

ORCHESTRA In the Greek theater, the space where the **chorus** sang and danced. Also, a large group of musicians playing various instruments. The **symphony** orchestra is the largest, containing around one hundred instruments. A chamber orchestra is smaller. See **chamber music.**

ORCHESTRATION Arranging and writing music to be played by an **orchestra.**

ORDERS In architecture, types of **columns** and **entablatures** distinguished by particular kinds of decoration and design. See **capital.** The three major orders are the Doric, Ionic, and Corinthian. See Figure 6.

ORIGINAL SIN A key doctrine of Catholic Christianity developed by St. Augustine (A.D. 354–430). When Adam and Eve disobeyed God and ate of the Tree of Knowledge of Good and Evil (the **Fall**), the consequences of that sin were transmitted to their offspring, that is, every human being. Thus, we are born in a state of sin, unable to resist evil on our own. Only God's grace can heal and restore our souls.

ORPHEUS Legendary Greek poet who sang and played the lyre so beautifully that rocks, rivers, and animals would follow him.

ORWELLIAN Adjective from British writer and journalist George Orwell (1903–1950). Commonly used to invoke the kind of world and political values described in his novel *1984* (1949), which is about a **totalitarian** society (similar to the now defunct Soviet Union) in which the government controls all aspects of life, especially speech and ideas, and brutally enforces adherence to its **ideology** and punishes dissent.

OTTOMAN EMPIRE The **Islamic** empire created in modern Turkey at the end of the thirteenth century. It eventually conquered the **Byzantine** empire and in A.D. 1453 sacked Constantinople,

now known as Istanbul. After **World War I** the Ottoman Empire was reduced to the territory of modern-day Turkey.

OVERTURE Music that introduces an **opera, oratorio,** or **ballet.** A concert overture is written for an **orchestra** but not intended to introduce anything else.

OXYMORON A contradictory phrase such as *hot ice* or *dry water:* A well-known joke is to say that *military intelligence* is an oxymoron. In literature, it is a device used deliberately to create an effect of **ambiguity** or complexity of thought. Alexander Pope's famous definition of a human in his *Essay on Man* (1733), "A being darkly wise, and rudely great," captures the contradictory nature of a creature with a material body of appetites and passions, and an immaterial mind that can imagine and reason.

PACIFISM, pacifist The belief that war is never justified under any circumstances.

PAGAN, paganism A pagan is what Christians called the people around them who weren't Christians; *paganism* was the general term for all non-Christian religious beliefs.

PALAEOLITHIC The first part of the **Stone Age,** when people hunted, fished, and used stone tools created by flaking rocks, starting 2.5 million years ago in Africa and ending around 10,000 B.C. The earliest works of art, such as paintings in caves (e.g., in Lascaux, France) or small statues of women with exaggerated sexual features (e.g., the Venus of Willendorf), are dated to the later Palaeolithic.

PAN Greek god associated with fields, woods, and shepherds; inspirer of sudden fear or "panic." Like the **satyrs** he is sexually aggressive. He is associated with the "Pan-pipes," an instrument made of seven reeds of various lengths.

PANTHEISM The belief that all reality is unified and divine, including the material world. Thus, pantheists see no distinction between God and creation, as does Christianity. More generally used of the belief that there is some sort of divinity or spiritual reality in **nature.**

PAPACY, the Generally, the office of the Pope, the head of the Roman Catholic Church; more particularly, the government of the Catholic Church whose most important officer is the Pope. In Catholicism, the Pope is considered the heir of the **apostle** St. Peter through an unbroken spiritual lineage, and hence he is the representative of Christ on earth.

PARADIGM SHIFT A phrase popularized by Thomas Kuhn in his *The Structure of Scientific Revolutions* (1962). Kuhn argued that scientists work in an accepted context of beliefs or **theories** called a paradigm, an accepted picture of the world that conditions the way we think about it. At some point, however, the paradigm is no longer adequate to the evidence and a new paradigm comes into being—and that is the paradigm shift. Kuhn's idea was a challenge to the belief that scientific knowledge progressed gradually and logically, with better argued theories replacing less sound ones.

PARADOX, parodoxical Something that is self-contradictory but appears to be true; also something that contradicts common sense but is still true.

PARIS Trojan prince who runs off with the Greek woman **Helen** and starts the **Trojan War.**

PARNASSUS A mountain in Greece near Delphi, associated with the worship of Apollo and the **Muses.** Near it is the Castalian

spring. Parnassus and the Castalian spring are frequently used as **symbols** of poetic creativity, achievement, and inspiration.

PARODY Imitating and exaggerating the **style**, technique, or attitude of an author or artist to make it humorous or ridiculous. Mel Brooks's films or the *Naked Gun* movies are cinematic parodies. In literature parody is a useful technique for deflating the pretensions and self-importance of writers, particularly if the purpose is not just to ridicule but to offer serious criticism. Henry Fielding's novel *Shamela* (1741) parodied Samuel Richardson's *Pamela* (1740), about a serving girl who resists her aristocratic employer's attempts to seduce her until he proposes marriage. Fielding's parody makes the important point that Richardson implies **virtue** is merely a means to a material end, not an end in itself.

PARTHENON The ancient Greek temple to Athena on the **Acroplis** in Athens, constructed 447–438 B.C. under the supervision of Phidias.

PASSCHENDAELE, Battle of A particularly horrible battle fought during **World War I** (July 31 to November 10, 1917). For no strategic or material gain the British suffered 300,000 casualties. See **trench warfare.**

PASSION The final events in Jesus' life, from the Last Supper to the Crucifixion, including his agony and fear in the Garden of Gethsemane; his betrayal by Judas with a kiss; the trial before Pontius Pilate; the torture with whips and the crown of thorns; and the bearing of the cross to Golgotha, the site of the Crucifixion.

PASSION PLAY **Dramas** in the **Middle Ages** whose subject was the Crucifixion and Resurrection of Christ.

PASTORAL A poem, **drama,** or painting that uses shepherds and rural life in order to talk about **ideas** that seldom occur to such people. Pastoral finds complex and sophisticated **themes** in simple **characters** and **settings.** Pastoral is also characterized by

a nostalgic idealization of rural life, a high value placed on love, creativity, peace, and freedom, and a conception and depiction of **nature** as a beautiful, timeless setting that harmonizes with human desire and aspiration. Pastoral quickly becomes sentimental and stereotyped, tending to the artificial and contrived. The best pastoral (such as the Roman poet Vergil's *Eclogues* [42–37 B.C.]) avoids this danger with a recognition of everything that limits pastoral idealism, such as the forces of time, history, society, and nature's destructiveness. In the twentieth century pastoral is not so much a **genre** as a way of looking at the relationship between the city and country, or the contrast of idealized dreams and a limiting reality. See **Arcadia, Golden Age.**

PATHETIC FALLACY A term coined by John Ruskin in the third volume of *Modern Painters* (1856) to describe the attribution of human emotions to nature. As with all poetic effects, to **personify** nature for a purpose is unobjectionable; the device becomes absurd when it is overdone or exaggerated, and dangerous when it suggests that there is no distinction between humans and the natural world. See **anthropomorphism.**

PAULINE Adjective used to describe religious doctrines and **theology** consistent with those of St. Paul (c. first century A.D.) in the New Testament.

PEASANTS' WAR An uprising from 1524–1526 during the **Reformation.** Peasants who were suffering economic hardship and incited by radical **Protestant** preachers raided and plundered until they were crushed, with over 100,000 killed.

PEDIMENT On a building, particularly a Greek temple, the triangular space between the **entablature** and the sloping sides of the roof, frequently filled with sculptures.

PELOPONNESIAN WAR The war fought between **democratic** Athens and **oligarchic** Sparta from 431–404 B.C. It ended with Athens's defeat and near destruction by Sparta and her allies.

PENTAMETER See **meter.**

PENTECOST A Jewish festival; on this day ten days after the **Ascension** of Christ, the **Holy Ghost** descended upon the **Apostles.** This event marks the beginning of the Apostles' mission to preach the word throughout the earth.

PERICLEAN ATHENS A term sometimes used to describe ancient Athens when it was at the height of its military, economic, and cultural power, around 450–400 B.C. During that period the **Parthenon** was built, **tragedy** and **comedy** were perfected, and **philosophy** flourished.

PERSEPHONE The beautiful daughter of **Demeter** who is kidnapped by **Hades** and taken into the underworld. She returns to her mother for six months of the year, the seasons of spring and summer.

PERSIAN WARS The two attempted invasions of Greece by the Persians, the first in 490 B.C. by Darius (see **Marathon**); the second in 480–479 B.C. by Darius's son Xerxes (see **Thermopylae, Salamis**). The conflict arose out of the mainland Greek cities' support of the Ionian (the coast of Turkey) city-states that wanted freedom from Persian domination. The Greeks' success at turning back the numerically superior, vastly more powerful Persians contributed to the Greeks' self-confidence and belief in the superiority of their consensual governments that fueled the cultural explosion of the fifth century, especially in Athens.

PERSONIFY To give human attributes to animals, gods, or objects. See **anthropomorphism.**

PERSPECTIVE The illusion of three-dimensional space in a painting, and the depiction of objects and persons so that they appear to be three-dimensional and to occupy a space beyond the flat plane of the picture. The most common type of perspec-

tive is called linear perspective, in which all the lines and edges of objects are drawn in such a way that they converge at the vanishing point, and the objects themselves get smaller as they approach the vanishing point.

PETITIO PRINCIPII Latin term for **begging the question.**

PHILISTINES Originally a group of people who settled in ancient Palestine around the twelfth century B.C. and who came into conflict with the Israelites, as described in the Old Testament. In *Culture and Anarchy* (1869), Matthew Arnold used the term *philistine* to describe people who were more interested in money and social status than in artistic or intellectual values.

PHILOSOPHE A French word used to describe the intellectuals and writers who were active during the eighteenth-century **Enlightenment** and who endorsed its principles and goals. See **Enlightenment.**

PHILOSOPHER-KING An idea derived from Plato's *Republic* (fourth century B.C.). Plato's ideal state is ruled by what he calls "Guardians," an elite group educated in **philosophy** and mathematics and, thus, presumed to be knowledgeable about the **good** for the state and its citizens. More generally, a belief that the best-ordered state would be one in which power resides in the hands of a philosopher, someone trained to think rationally and make decisions based on what is best for the state. See **utopia.**

PHILOSOPHY, philosophical Sometimes casually used to mean something such as "worldview" or "system of values." More precisely, philosophy is the self-conscious, systematic, **rational** (rather than supernatural) investigation of fundamental issues such as existence (**ontology**), knowledge (**epistemology**), **ethics,** and **political** ideas (forms and types of government, who participates, etc.). This kind of philosophy was invented in the sixth century B.C. in

ancient Greece and included areas of study, such as religion and the gods, that later become the subjects of **theology**, and physics or astronomy, which we now consider the business of science. See **metaphysics, theology.**

PHRASE A short section of music, usually two to four **measures** long, ending with a **cadence.**

PICARESQUE A kind of literary **narrative** that developed in Spain and tells of the adventures of the *picaro,* a rougish **hero.**

PICTURESQUE Means picture-like. Used for seventeenth-century **landscape** paintings and natural scenery similar to such paintings.

PIER A vertical support in a building, differing from a **column** in that it is square in shape rather than round.

PIETÀ An artistic **scene** that features the Virgin Mary with the dead Christ.

PIGMENT The substance that gives paint its color, derived from any number of sources such as clay, plants, and so on, and mixed with a base (oil, egg, etc.).

PILGRIMAGE, pilgrim A journey to visit and worship at a religious shrine in order to fulfill a vow or as penance (an act intended to show regret for sin). Pilgrimages were popular in the **Middle Ages,** especially journeys to the **Holy Land.** The *Canterbury Tales* (c. 1387) by Geoffrey Chaucer (c. 1342–1400) describes a group of pilgrims on their way to Canterbury, where Thomas á Beckett, archbishop of Canterbury, was assassinated (1170). After the **Crusades** Jerusalem was a popular destination, as was Santiago de Compostela in Spain, site of the martyrdom of St. James.

PILGRIMS, the; Pilgrim Fathers The 102 founders of the Plymouth Plantation in Massachusetts in 1620. They left England to escape religious persecution. See **Puritans.**

PITCH The highness or lowness of a **tone.**

PLATONIC An adjective that describes the **philosophy** of the Greek Plato (c. 429–327 B.C.) or views influenced by Plato. As an adjective it usually suggests **idealism,** a view that truth and beauty exist in an immaterial, unchanging realm that is only imperfectly mirrored in the mutable (ever-changing) material world and that is accessed through **reason** rather than the senses.

PLATONISM The philosophical doctrines of Plato or of those who claim to be followers of Plato. Sometimes used for a key component of Platonic philosophy, such as **rationalism** or the theory of **forms.** See **form.**

PLOT The pattern and sequence of events and actions in any story.

POETIC LICENSE The freedom of the poet to depart from the usual standards of subject, language, word order, **diction,** and so on when creating a poem.

POETICS The systematic study of poetry; **theories** and definitions of various kinds of poetry, their resources, techniques, and purposes, as well as the identification of what makes poetry unique compared to other forms of literature.

POETICS, The A fragmentary work by Aristotle (384–322 B.C.) that analyzes and defines **tragedy** and **epic.** Key ideas that influence later **criticism** include the idea of **mimesis;** the view of literature as **catharsis** (a spectacle that arouses and discharges the emotions of pity and terror in the audience); the idea that the **tragic hero** is in status higher than the audience yet still flawed;

the idea of the **tragic flaw** (*harmatia*) that brings on the hero's overthrow; the scene of recognition, when the hero realizes his flaw has contributed to his downfall; and the statement that poetry is more **philosophical** than history because the former communicates general truths, whereas the latter focuses on particular facts.

POINT OF VIEW In talking about a story, point of view refers to the perspective from which the story or some part of it is told. If the author tells the story with an ability to enter the characters' minds, foresee the future, and know the past, we call that point of view omniscient or all-knowing. A character who tells the story is a first-person **narrator** (an "I") whose point of view will obviously be limited to what that character can know and experience. Other characters can tell the story, or several characters can alternate, or an omniscient narrator can let the point of view be influenced by a character whose own perception or judgment is privileged, as is Elizabeth Bennett's in Jane Austen's *Pride and Prejudice* (1813). Or a writer can combine all sorts of points of view. The manipulation of point of view is useful for creating suspense and duplicating the ambiguity and uncertainty of our experience of people and events, or for providing alternative interpretations and judgments of events and characters.

POLIS Ancient Greek word for **city-state.** The Greek polis was characterized by a constitutional government ruled by citizens, whether these were narrowly or broadly defined, and by the subordination of most of public life, including art and religion, to the demands of the polis.

POLITICS, political Most simply, political and politics refer to the art, **theory,** practice, and science of governing and/or the techniques for acquiring office and governing power. Some **poststructuralist** literary critics use these terms to refer to the issues of public and social **power** relations that they believe to a greater or lesser extent also dominate art and literature and ultimately

account for their effects. How power is socially distributed, which groups are excluded and marginalized, which groups are privileged and dominant, the principles of exclusion (appearance, **gender,** class, race, sexual preference)—these are all political issues. Hence, politics is the ultimate determinant of literary forms, **genres, themes, imagery,** and technique, because all these apparent literary issues really are devices for simultaneously reinforcing and obscuring a power hierarchy based on exclusion. See **power, deconstruction, poststructuralist, historicist.**

POLITICAL PRISONER A person jailed not because he or she has committed any crime but because he or she advocates or communicates views that threaten those in control of the government.

POLYPHONIC, polyphony Polyphonic music is written for performance by more than one voice.

POLYPTYCH See **altarpiece.**

POLYTHEISM, polytheistic Belief in more than one god. All ancient religions except **Judaism** were polytheistic. See **monotheism.**

POP ART A type of art from the midtwentieth century that focused on everyday consumer goods such as soup cans, or subjects from the **mass media** such as Marilyn Monroe or comic strips. Andy Warhol (1928–1987) is the most famous pop artist.

POPULAR CULTURE Popular music such as rock-and-roll, advertising, movies, television, novels, food, consumer goods that are mass-produced and mass-consumed, as opposed to high **culture,** which is presumably more complex or sophisticated and, hence, enjoyable to an elite. In some forms of analysis such as **poststructuralism,** the distinction between high and popular culture is considered artificial and dishonest because all a society's productions are subject to the same **political** forces and limitations. See **culture.**

POPULISM, populist A **political** stance that champions the common people and their interests over those of various elites.

PORTRAIT A painting that depicts an actual human being, whether the depiction is **realistic** or idealistic.

POSEIDON Greek god of the sea, also associated with earthquakes and horses.

POSITIVISM, positivistic A movement (initiated by Auguste Comte, 1798–1857) that viewed knowledge as the result of progressive development, with the latter stages having greater value and reliability. Science is, thus, considered the only legitimate model for acquiring true and reliable knowledge. When applied to history, positivism considers that the goals and **empirical** methods of science should be applied to determining the truth about the past. This can lead to positing universal laws, such as the laws of the natural world, that govern human history; or, in contrast, favoring particular facts and ignoring generalizations. In any case, the assumption is that the **objective** truth about the past can be obtained if one follows the methods of science. See **empiricism.**

POST HOC, ERGO PROPTER HOC Latin for "After this, therefore because of this." A logical **fallacy** that believes event B was *caused* by event A just because event B occurred *after* event A.

POSTMODERN, postmodernist, postmodernism As a term of art and literary history, *postmodern* refers to art and literature created after the mid-1960s, and to certain ways of thinking that share some of the same concerns. The principles of postmodernism at one level continue those of **modernism**—a concern with experimentation in technique and **form;** alienation from a mass industrial society seen as destructive, bureaucratized, crass, and materialistic; historical discontinuity and the breakdown of tradition; and expressive **individualism.** Postmodernism differs from modernism in the former's greater interest in nonartistic activities and **popular culture,** and its leveling of the distinctions

between high art and popular culture, with a fondness for **parody**; a view of language as a self-reflexive object of interest in itself rather than as a means for expressing truth; a profound distrust of anything, especially language, that claims accurately and **objectively** to represent reality; and in postmodernism's denial of a stable creative order that can substitute for the fragmented social world and provide an alternative foundation for human meaning and identity—to postmodernism, there are *no* foundations, neither for human meaning, identity, art, nor morality. Everything is fragmented and free-floating, including artistic forms, which are now completely open to unbridled experimentation, and the individual, who is no longer **psychologically** integrated but rather a bundle of neuroses, complexes, and multiple identities battered by indifferent cosmic, historical, and social forces. To the postmodernist sensibility, the only authentic response is to revel in the freedom of psychological, artistic, and moral possibilities created by the breakdown of traditional society and its outmoded conceptions of a unified human psychology. The American Thomas Pynchon's *Gravity's Rainbow* (1973) perhaps represents best the postmodern **novel**. See **absurd, modern art, pop art, modernism, poststructuralism.**

POSTSTRUCTURALISM This term refers to a wide variety of literary criticism that has in common a distrust of a firm, transcendent, meaning-generating foundation and structure, whether this foundation is thought to reside in God or the soul, language, nature, society, or literature itself (as **structuralism** implies, hence, *poststructuralism*), or in reason's power to discover **objective** truth and meaning, or in the individual's integrated identity and **consciousness.** In the poststructuralist view, there is no foundation, no place one can stand and be free from the chaotic effects of language's continual deferral of meaning and obscuring of meaning's absence, or from **power**'s ruses and mechanisms by which it legitimizes itself and obscures its principles of marginalization, exclusion, and oppression. See **deconstruction, historicism, structuralism, theory.**

POWER A vague and slippery term whose popularity derives from the work of the late French philosopher Michel Foucault (1926–1984). Foucault asserted that human relations are characterized by hierarchies and dominance, the imposition of power over another person, even at the level of individual interactions. These power relations are institutionalized in a society at every level and in every activity, including the determination of what is true or good, and how we can officially speak about and define people, especially **psychologically.** What appear to be absolute, true ideas and concepts (especially race, gender, sexual preference, and class), including so-called scientific ones based on an accurate description of human experience, are really deceptive justifications for existing power relations and their mechanisms of privilege and exclusion, particularly as these are inscribed in official discourses that claim to communicate the truth about humans. This deception is true of literature as well, whose **aesthetic** values and lofty ideals are really mystifications of arbitrary and historically determined power relations and political privilege. Literary analysis motivated by these ideas seeks to unmask these deceptions and reveal the oppression of excluded groups hidden beneath the pleasures of literary beauty. See **politics, deconstruction, historicism.**

PRAGMATISM, pragmatist The view developed in the United States by Charles Sanders Peirce (1839–1914) and William James (1842–1910) that observable, practical efficiency and consequences—whether something works effectively or not in the world of experience—are the most important criteria for establishing the truth of a statement or the rightness of an action. There is disagreement over who judges whether an idea "works" or not. Some pragmatists think something works if it achieves some impersonal purpose, others believe something works if it achieves a particular person or group's aims. See **positivism.**

PRE-COLUMBIAN Adjective used to describe the history, **culture, civilizations,** societies, and art of the peoples living in North and South America before Columbus arrived in the **New World.**

PRECONTACT Another way to say **pre-Columbian.**

PREDESTINATION The idea that God through his absolute knowledge guides those ordained for salvation. See **Calvinism.**

PREHISTORY, prehistorical Prehistory is the study of humans before the advent of written history, which occurs at different dates in different parts of the world. In the Near East, the first written records begin about 3000 B.C. The prehistorical period is usually divided into the **Stone Age,** the **Bronze Age,** and the **Iron Age.**

PRELUDE In music, a **composition** that introduces a larger work, such as an **opera.** Sometimes written as independent works.

PRE-OLYMPIANS In Greek myth, the gods and divinities who come before the **anthropomorphic Olympians,** including the **Titans.** The pre-Olympians tend to be more monstrous, grotesque, and elemental, connected to the primal forces of **nature** such as fertility, death, sex, and so on.

PRESENTISM, presentist Judging or evaluating the past in terms of the values, knowledge, and assumptions of the present rather than those of the period in question.

PRE-SOCRATICS The Greek philosophers before Socrates, including Thales (sixth century B.C.), Anaximander (c. 550 B.C.), Anaximenes (c. 550 B.C.), the so-called Milesians, from the city-state of Miletus in Ionia, Anaxagoras (500–428 B.C.), Democritus (c. 460–c. 370 B.C.), Xenophanes (c. 560–c. 470 B.C.), Heracleitus (c. 500 B.C.), Parmenides (c. 480 B.C.), and Pythagoras (c. 550–500 B.C.).

PRIMARY COLORS The three basic **hues** of red, yellow, and blue, which mixed together can make any other color.

PRIMITIVISM The self-conscious cultivating of a **style** or values associated with less civilized, less **technological**, less **rational**, less socially sophisticated tribal peoples, especially from Africa, the Americas, and Oceania, who are presumed to live more closely to **nature** and so are free from the corruption and anxieties of sophisticated urban life. See **Golden Age.**

PRINT An image that can be duplicated. See **etching, woodcut.**

PROGRAM MUSIC A musical work that has some purpose other than just music—communicating a mood, describing nature, interpreting an event, and so on. Stravinsky's *Rite of Spring* (1913) is a famous example.

PROGRESS The belief that human life and its conditions will improve through time because of advances in **scientific** knowledge and **technology.** At one level progress is a fact of history because material conditions for many people have improved, more is known about the world, and more people are educated. Others view progress as a **myth** that ignores the many ways in which people are worse off; for example, some argue that modern people, though materially better off, are spiritually impoverished and so have declined from earlier times. See **Golden Age.**

PROGRESSIVE A **political** view that favors moderate political, economic, and social change conducted by government action. See **liberal, leftist.**

PROLETARIAT In **Marxist** thought, the proletariat is the class of people who work for wages, especially in factories. They are the class exploited and oppressed by the **bourgeoisie,** who own and manipulate capital. Marxism believed that the proletariat would lead the revolution that would abolish private property and create **communism.** See **Marxism.**

PROMETHEUS, Promethean In Greek myth Prometheus saves the human race by stealing fire from heaven and giving it, along

with **culture** and **technology,** to humans. The adjective refers to the view that humans survive because of their minds and crafts.

PROPAGANDA Mass-distributed writing or **symbolic** images intended to shape and control public opinion, beliefs, and actions.

PROSCENIUM The part of the stage in front of the curtain; also an archlike structure that separates the stage from the audience.

PROSE Writing, whether **fiction** or **nonfiction,** which is not written in poetic **meter.**

PROSODY The systematic study of **meter** in poetry. See **meter.**

PROTESTANT ETHIC A term popularized by Max Weber in *The Protestant Ethic and the Spirit of Capitalism* (1905). A view of human life and good based on hard work; self-denial; a simple, sober lifestyle that avoids excess and luxury; **reason;** and the moderate pursuit of material wealth, which was a sign of God's favor. Weber linked the Protestant ethic to the rise of **capitalism,** whose pursuit of wealth was given a spiritual justification by Protestant doctrine.

PROTESTANTISM, Protestant Protestantism is the version of Christianity that split off from the Catholic Church at the **Reformation** initiated by the teachings of Martin Luther (1483–1546). Protestantism is characterized by the direct relationship between the individual believer and God through the Bible, without interpretative intermediaries such as priests; a reliance on the individual's judgment in spiritual matters; "justification by faith": That is, one cannot work one's way to heaven through good deeds ("works") but is dependent on God's undeserved grace; a simplified service without elaborate ritual, music, vestments (priest's clothes), or expensive artwork or architecture; the importance of preaching and hearing the Gospel over ceremony or **sacraments.** See **Reformation, Calvinism, individualism.**

PROVIDENCE, providential The idea that the whole world, including **nature** and human beings, is created by God or a god according to an eternal **rational** plan whose larger goal or purpose is ultimately good. Thus, every detail of creation and every event in history—no matter how seemingly evil or bad—have its meaning and explanation in terms of this larger plan and its ultimate good. In Christianity, the goal or end is the return of the saved to God and the end of material space and time. As a view of history, providence sees all the events of history from the Creation to the Second Coming as also occurring according to this plan and serving its ultimate goal. See **salvation history**.

PSYCHOLOGICAL, psychology Generally, the systematic study of the human personality and behavior. In literary analysis, a term that refers to the depiction of mental states, will, emotions, motives, memories, behavior, and personality—everything that makes up a person's identity. In fiction psychology refers to the way an author develops a character and gives him or her a believable identity, explores motivation for actions, records the influences that other people and events have on that development, and/or documents past experiences, wishes, dreams, desires, and so on that likewise account for external behavior and actions and the changes in a person's identity and sense of self. See **novel**.

PTOLEMAIC Adjective that refers to the picture of the universe created by the Greek astronomer Ptolemy (second century A.D.), in which the earth is in the center and the sun, moon, and planets revolve in spheres around the earth. See **Copernican**. Also used to refer to the Greek kingdom, dynasty, and culture that developed in Egypt following its conquest by Alexander the Great, from Ptolemy (323–283 B.C.), the Macedonian general who seized Egypt after the death of Alexander. Ptolemaic Egypt was eventually absorbed into the **Roman Empire** after the death of Cleopatra VII (68–30 B.C.).

PUN The use of a word in such a way that suggests two or more of its meanings, or another word similar in sound. Puns are another device writers can use to pack more meaning and complex ideas into their language, or to suggest ambiguity. Shakespeare is very fond of puns, as when Hamlet puns on *sun* and *son*: "CLAUDIUS: How is it that the clouds still hang on you?/HAMLET: Not so, my lord. I am too much in the sun" (I.ii.66–67). The last line carries two meanings: "I am too much in the light of unwanted royal attention," as the sun was a traditional **symbol** of the king; "I am too much in the distasteful role of a son" because the despised weak Claudius married Gertrude, Hamlet's mother.

PUNIC WARS Three wars fought between ancient Rome and Carthage, a powerful city on the north coast of Africa. The First Punic War (264–241 B.C.) saw the Romans develop a fleet and take control of the islands of Sicily, Sardinia, and Corsica. In the Second Punic War (218–201 B.C.) the Carthaginian general Hannibal invaded Italy and defeated the Romans at three major battles (see **Cannae**) but could not deliver a knock-out blow and had to retreat to Carthage when the Romans landed in North Africa. The Romans defeated the Carthaginians at Zama (202 B.C.), and the Carthaginians effectively lost all their colonies to the Romans, the most important being Spain. Finally, in the brief Third Punic War (149–146 B.C.) Carthage itself was beseiged and utterly destroyed. The result was the complete dominance of the western Mediterranean by the Romans and their arrival as the dominant power.

PURGATORY In Catholic Christianity, a place where souls after death can work off sins through punishments or through the prayers of the living in order to become fit for heaven.

PURITANISM, Puritan Seventeenth-century English **Protestants** who believed the Church of England was too similar to

Catholicism and, thus, wanted to "purify" the church of doctrines and practices that were not biblical. They were also ethically and morally strict: They believed the theater, for example, was immoral, and during the Puritan dominance (see **Puritan Revolution**) closed down the theaters. Many left England and settled in America. See **Calvinism, Protestantism, Reformation.** Today *Puritan* is a mostly negative term used to characterize someone who is excessively anxious about immoral behavior, particularly sexual behavior, and who desires to control the behavior of others, a caricature popularized by Nathaniel Hawthorne's *The Scarlet Letter* (1850). The historical Puritans, in actual fact, were not as opposed to sexuality as sometimes believed; for example, Puritans accepted sexual pleasure between married people as intended by God to strengthen the marital bond.

PURITAN REVOLUTION Another term for the Civil War that broke out in England in 1642 between the Puritans, lead by Oliver Cromwell (1599–1658), and the royalists remaining loyal to Charles I (1600–1649), who was beheaded in 1649 after the royalists' defeat. England was ruled by Cromwell as Lord Protector from 1653 until his death.

PURPLE PATCH An image from the Roman poet Horace's *Ars Poetica* used to describe the insertion in a poem of an unnecessary element that is elaborately detailed. More generally used for an unnecessary and overly showy passage that stands out from its context.

PUTSCH A secretly plotted attempt to overthrow a government.

PUTTO, putti A chubby nude boy with wings, used as a decoration in **Renaissance** art especially. If putti carry bows and arrows, they are associated with the god of sexual desire, **Cupid,** and are called *cupids* or *amoretti.*

Q

QUADRIVIUM The part of the curriculum of a medieval education including arithmetic, astronomy, geometry, and music. See **seven liberal arts.**

QUARTET A group of four instruments, or singers who perform music written for such a group.

QUATRAIN A four-line section of a poem. See **sonnet.**

QUINTET A group of five instruments, or singers who play music written for such a group.

QUISLING A political leader who supports and aids the invaders of his country. From the Norwegian **fascist** Vidkun Quisling, who helped the Germans conquer Norway in **World War II** and then headed up the pro-German government.

QU'RAN See **Koran.**

R

RACE, racist, racism, racialism Race is the idea, starting in the eighteenth century, that human beings can be biologically divided into different kinds on the basis of physical characteristics such as skin color, facial features, hair texture, and so on. This idea is unknown in the ancient world, which divided people on

the basis of **culture** and language. Racism and racialism, which mean the same thing, are the belief that based on these presumed biological differences, there exist as well intellectual differences, and so some races are less intelligent and able or "human" than others. Thus, they can be legitimately restricted in their **rights**, exploited, or oppressed by the presumed superior race. Racism was respectable to many people in the nineteenth and early twentieth centuries, but the horrors of the **holocaust** discredited racism and it is now universally condemned, even if some people still believe in it. This term is frequently used sloppily to describe attitudes that technically do not embrace a belief in inherited inferiority. See **holocaust, genocide.**

RADICAL, radicalism A political view, usually but not always **leftist,** that advocates extreme, immediate, frequently violent change in order to stop injustice, oppression, or exploitation on the part of more powerful social groups or the government.

RATIONALISM Generally the view that the most important aspect of human identity is **reason;** indeed, that reason is what defines us as human beings and differentiates us from animals. Through reason a surer, more consistent, more orderly, and more truthful picture of the world and our place in it can be acquired than is the case through religious belief or mysticism. A more specific use of rationalism (associated with **Platonism**) refers to the belief that knowledge and truth can be discovered by thinking alone, without any **empirical** data, because some ideas are innate in the human mind and the physical senses are highly unreliable.

REALISM, realist As a **critical** term, *realism* refers to the attempt to represent the external world of nature and society and the internal world of human **psychology** accurately in art and imaginative writing, particularly the **novel,** without idealization. This means rendered accurate in terms of the everyday world—people, society, and behaviors—itself as it is commonly and communally perceived, rather than in terms of some ideal or other, whether

religious, artistic, or personally idiosyncratic. Sometimes realism refers to the nineteenth-century literary and artistic movement that tried to show the actual social world in which people lived, no matter how sordid or unpleasant, rather than just idealized or beautiful subjects. See **naturalism.**

Thus, realist paintings will depict objects or events or arrange **scenes** that do not necessarily have any **symbolic** or religious or other significance. Those objects are there because in life we frequently see objects that just happen to be there. In addition, the painting will use **perspective** to duplicate the way the real world appears to us when we perceive it. Moreover, realist paintings, especially those of the nineteenth century, are concerned with depicting accurately the realities of modern life, even if those realities are unpleasant or involve the lower classes. Often realist painters had a political agenda as well—they wanted to call attention to abuses or injustice or champion a particular political philosophy.

Realist novels (1) have stories that are like the experiences the reader has had or could have had; (2) present individualized characters who have psychological depth, past histories, names, behaviors, personalities, and motivations all developed at some level of detail, and similar to those possessed by people the reader could encounter outside his or her door, rather than by larger-than-life heroes or gods; (3) describe in more or less concrete detail the physical surroundings and appearance of the characters, which are particularized, and the social and cultural institutions, customs, and practices of the characters' time; (4) respect the laws of nature, time, and cause and effect. Many novels called realist, of course, violate some of these principles, but most of them have enough of these features to create an effect that the story is duplicating a reality recognizable beyond the story. In turn, literature that is not realist will use some of these devices to make its scenes vivid and give them the impact of experience. Dante's *Inferno* (1300), for example, has many vivid "realistic"

scenes but the poem is not realist, as its details are ultimately determined by its supernatural religious vision. Take care not to assume that *realistic* necessarily means "true." After all, the characters and stories of the great realist novels are all technically but not factually true. See **novel, romance.**

In **philosophy,** realism refers to the **medieval** view that true reality existed in independently existing, universal, abstract **ideas** rather than in things, which reflect those ideas. More generally today realism believes that the objects of sense perception or thought exist apart from our senses or minds. See **rationalism, form.**

REALPOLITIK German for "practical politics": the view that political decisions, especially those concerning foreign relations, should be based on practical, strategic, or material grounds rather than on ethical, moral, or **theoretical** ones.

REASON The human capacity to think coherently, solve problems, seek truth, and acquire knowledge, as opposed to instinct, emotion, divine **revelation,** or imagination.

RECITATIVE A kind of singing that sounds like speaking, used in **opera** and **oratorio.**

REDEMPTION In Christian **theology,** the saving of the human race from **original sin** by means of Christ's crucifixion and resurrection.

RED-FIGURED See **Greek vase.**

REFRAIN The part of a song repeated after each verse. In a poem, lines repeated at regular intervals.

REGISTER A range of sound a human voice or musical instrument can make.

RELATIVISM, relativistic As a theory of knowledge (**episte-mology**), relativism states that what we can know depends on our minds and the conditions of knowing. In extreme form, rela- tivism denies that there is any "reality" out there that we can know, and that is independent of the ways we know and organ- ize our thoughts, or is independent of the language in which we communicate what we know. See **subjective.**

Ethical or moral relativism states that there are no **absolute** standards or codes of behavior, but that rather these depend on the group that holds them in a specific place and time. Thus, there is no vantage point from which one can look at these vari- ous codes and rank or judge them. This term is sometimes used for what more precisely is ethical **nihilism**—that all moral stan- dards are arbitrary and accidental, literally meaningless, that, as Hamlet says, "there's nothing good or bad but thinking makes it so." This is different from believing that many standards exist, that they are nonetheless based on a perceived human **good** or truth, but that these standards are not identical everywhere and at all times, and so cannot be reconciled to each other.

As a belief about history, relativism denies that accurate infor- mation about the past can be acquired because every work of his- tory is limited by its own time, values, **culture,** morality, preju- dices, and so on, and these all will subtly shape and influence the selection and analysis of evidence.

RELIEF SCULPTURE Sculpture that projects from the surface on which it is carved rather than standing alone.

REFORMATION A movement in the sixteenth century in Ger- many and Switzerland, initiated by Martin Luther (c. A.D. 1483–1546), to reform the doctrine and practices of the Catholic Church from the corruption and abuses that had arisen over the centuries from the wealth and political power of the es- tablished church and the **papacy.** See **Protestantism.**

RENAISSANCE French for "rebirth." The period in European and especially Italian history, starting in the late fourteenth century and ending around the end of the sixteenth century, characterized by a renewed interest in **Greco-Roman** history, architecture, art, **philosophy,** and literature, and marked as well by a new confidence in human intellectual abilities and by a growing liberation of art and learning from the context, values, and dogmas of the Christian church. The recovery of previously unread or lost Greek and Roman literary works and works of art helped fuel this movement. See **humanism.**

REPRESENTATION, representational In art and literature, the idea that a painting or a piece of literature can accurately represent a reality (**nature,** society, individual **psychology**) external to the work of art.

REPRESSION A postulated (but not proven) psychological process whereby forbidden desires or impulses are banished from **consciousness** but remain in the **unconscious** where they affect behavior. See **Freudianism.**

REPUBLIC, republican A type of government characterized by supreme power residing in a body of citizens who vote for representatives and officers responsible to the people and governing according to the law.

REQUIEM A musical version of the Requiem Mass, the service for the dead in Catholicism.

RESTORATION A period in English history covering the late seventeenth century after the **monarchy** was reestablished with the reign of Charles II (1630–1685) and the **Puritan Revolution** ended. An adjective used to describe the literature and society of that time, which are characterized by greater moral freedom in manners and subjects, both of which had been restricted by the Puritans.

REVELATION In Christian **theology,** the means by which God communicates the truths of salvation to humanity through prophets in the Old Testament, through the life and teachings of Jesus, and then through the writings of the New Testament.

REVOLUTIONS OF 1848 A series of revolutions in Europe that opposed **autocrat**ic and aristocratic governments and demanded constitutional governments and greater political participation on the part of the middle and working classes. Though all the revolutions had failed by 1849, **feudalism** and **monarchy** had been seriously compromised as political ideals.

RHETORIC, rhetorical Originally the "art of persuasion," the science of using language and its devices in order to convince another person of one's position. In literary studies, rhetoric sometimes refers to the use or analysis of the figures of speech, **structure,** and other techniques and devices writers call on to communicate (or to obscure) their meaning or to create their effects. Rhetoric sometimes carries a negative **connotation** when it suggests a concern for the superficial qualities of language at the expense of the underlying meaning and its truth or value.

RHYME Duplication of the sound of stressed syllables at the end of lines of poetry, which is called end rhyme, or in the middle of lines, called internal rhyme. As well as pleasing the ear by making language musical, rhyme is useful for helping to organize the **structure** of a poem, emphasize the sense of words, and reinforce the **rhythm.** When rhyme is analyzed, the rhyme sound is given a letter: A six-line poem, for example, whose first line rhymes with the fourth, second with the fifth, and third with the sixth would have its rhyme pattern designated *abcabc.*

RHYME SCHEME The pattern of **rhymed** words or syllables in a poem, with rhymes identified by letters: the first rhyme is *a,* the next *b,* and so on.

RHYTHM In visual arts, the regular repetition and spacing of a **form** or element such as **columns** or windows in a building or shapes in a painting. In music, a regular **beat** as it proceeds through time.

In literature, the movement of language created by the conscious manipulation of the pattern of unstressed and stressed syllables. These patterns can be traditional and regular (see **meter**) or created by the poet, as in **free verse.** Good prose writers are conscious of rhythm as well. All writers use rhythm to make their language musically pleasing, speed or slow the movement of their words and sentences, help with the organization of ideas or **imagery,** and support the meaning, as when Keats in a line from *Ode to a Nightingale* (1819)—"Where palsy shakes a few, sad, last gray hairs"—uses a slow, jerky rhythm to reinforce the line's description of sickly old age. Or notice how Gerard Manley Hopkins, describing a hawk in flight, duplicates the bird's circling movement with his words' **anapestic** rhythm: "in his riding/Of the rolling level underneath him steady air, and striding/High there, how he rung upon the rein of a wimpling wing/In his ecstasy!" ("The Windhover," 1918). Note too the other effects—the internal **rhyme** of *air* and *there,* the repetition of the *r*'s and *w*'s and *h*'s, the striking image of the wing as a "rein" that both guides and restrains the bird.

RIGHT, the; rightist A term used to describe **conservative** political beliefs and principles, including opposition to political and social innovations and a preference for traditional practices and values. See **conservative.**

RIGHTS A right is a justified claim to a privilege, an interest, or a power to do something. See **natural rights.**

ROCOCO An eighteenth-century artistic **style** that developed out of the **Baroque,** characterized by frivolous subject matter, curved shapes, and lush and elaborate ornamentation and

decoration. In music history, rococo describes a kind of music that is light and frivolous.

ROMAN à CLEF A **novel** in which real people and events appear under disguise.

ROMANCE, medieval romance A kind of fiction whose stories, settings, and characters are exaggerated, highly idealized, exotic, and adventurous. Characters in romance are underdeveloped **psychologically** and **stereotypical** in their features, corresponding to an ideal type both in social class, appearance, and abilities rather than to the sorts of average people the reader could know. The social, cultural, and historical settings are remote and exotic in time and place but vague and sketched in rather than elaborated in detail and particularized. Events and actions are freed from the strictures of natural law, the supernatural and miraculous occurring frequently in romance. Finally, love is a frequent **theme.** The **medieval romances** about King Arthur, Guinevere, and Lancelot typify this sort of fiction. Romance obviously contrasts with **realism,** but stories do not always stick completely to one or the other, sometimes having a mixture of romance and realist elements. A good contrast of a character described in terms of romance and one developed more in realist terms can be seen in Chaucer's descriptions of the Knight and the Wife of Bath in *The Canterbury Tales* (c. 1387). See **novel, realism.**

ROMAN EMPIRE The period of history when the ancient Mediterranean, Europe, and much of the Near East were unified under the political and military control of the ancient Romans (27 B.C.–A.D. 476).

ROMANESQUE The artistic style of the **Middle Ages** (A.D. 900–1200), especially in architecture, characterized by ancient Roman architectural features such as thick walls, semicircular arches, and **barrel vaults.**

ROMAN REPUBLIC The government of ancient Rome from the eighth century B.C. to the creation of the **Roman Empire** (27 B.C.). The republic was characterized by rule through a deliberative legislative body called the Senate and elected magistrates with limited tenures rather than through a king or inherited aristocracy.

ROMANTICISM, romantic *Romanticism* is a notoriously slippery term, so what follows is to be understood at a very general level. As an artistic and literary movement of the late eighteenth and the nineteenth centuries, romanticism reacted against the formal rules and standards of decorum of **neoclassicism,** which were considered to be artificial and to restrict the expressive, dangerous (to a mediocre society) genius of the individual. Whereas neoclassicism prizes restraint, balance, rationalism, and an interest in people as social animals, romanticism puts the individual and his or her creative imaginative power and expressive passions and feelings, no matter how extreme or even destructive, at the center of its ideals. Rather than neoclassicism's concern with order both politically and artistically, romanticism enthuses in the wild, the primitive, the uncivilized, the exotic, the unrestrained, the quirky, the deviant, the peculiar, sometimes even the perverse, sordid, and criminal—anything that expresses a unique individualism standing out from the dull, standardized, safe, tame rationalism and rules associated with the **philistine** middle class obsessed with status and money. The individual's spontaneous and intense response to feeling and beauty—and anything that arouses both, especially nature, sexuality, and art—is also a romantic ideal. Finally, the individual creative imagination, particularly that of the lone artistic genius, is considered the faculty far better able to discover the significant transcendent truths of the human condition than are the plodding rules of reason and logic, which are useful only for discovering less important material facts. Many writers in English can be characterized as romantic based on these criteria, including in England John Keats, Percy Shelley, William Wordsworth, Samuel Taylor Coleridge, and many others. One should recognize, however, that even in the

work of romantic poets there are elements not technically romantic, and that writers over their lives develop and change their minds about issues and, thus, are often difficult to pin down with one general term. The German writer Johann Wolfgang von Goethe's influential *Sorrows of Young Werther* (1774) is a good introduction to the ideals of literary romanticism. See **classicism.**

ROMULUS AND REMUS Twin brothers who in Roman legend were raised by a she-wolf. They quarreled at the founding of the city, with Romulus killing his brother and, thus, giving his own name to the new city.

RONDO A musical form that alternates a recurring principal **theme** with other material contrasting with the theme. Used in **classical** music as the final movement of the **sonata,** the **string quartet,** the **conerto,** and the **symphony.**

ROSE WINDOW In a **Gothic cathedral,** a round, intricately patterned stained-glass window usually found in the front or back wall.

RUSSIAN REVOLUTION The overthrow of Csar Nicholas II in 1917 and the eventual establishment, after three years of civil war (1918–1921), of **Communist** rule in Russia, and the creation of the Union of Soviet Socialist Republics (USSR), which collapsed in 1989. See **Bolshevik.**

SACRAMENTS, sacramental Ritualistic acts in Christianity that represent a spiritual reality, one specifically involving the individual's relationship to God and the revelation of God's presence to the individual. The Catholic Church recognizes seven sacraments:

Baptism, Confirmation, **Eucharist** (Communion), Penance, Extreme Unction (the dying person's last confession), Holy Orders (becoming a priest), and Marriage. **Protestant** Christianity recognizes only two, Communion and Baptism.

SAINT BARTHOLOMEW'S DAY MASSACRE The murder of about 3,000 French **Huguenots** in Paris August 23–24, 1572. One of the worst atrocities in the wars between the Catholics and **Protestants.**

SALAMIS, Battle of A naval battle between the outnumbered allied Greek **city-states** and the Persians near the island of Salamis (480 B.C.). The Greek victory seriously weakened the Persian attempt to subdue Greece. The Persian threat was ended the next year after the land battle at Plataea and another sea battle near Mycale in what is modern-day Turkey. See **Greco-Persian Wars.**

SALVATION HISTORY The Christian interpretation of history as organized around God's good intentions for the human race, covering the whole expanse of created time from Creation to the **Second Coming,** and including key events such as the **Fall,** the **Incarnation,** the Crucifixion, the establishment of the Church, the Second Coming, and the Last Judgment, when time will be no more. See **providence.**

SANS-CULOTTES French for "without knee breeches." A member of the army created after the **French Revolution,** who favored long pants over the knee breeches worn by the aristocracy. Later a term used to describe a radical **republican** or violent political extremist.

SARACENS A European term used to describe **Muslims.** See **Islam.**

SATIRE, satiric A kind of literature that uses humor and wit to criticize and chastise society and its hypocrisies and vices,

originally in longish poems such as those written by the Roman poets Horace (65–8 B.C.) and Juvenal (born c. A.D. 60–70), later in **novels** as well. Satire can range from the mild and gentle to the bitter and savage, but both kinds usually focus not on individuals but on recognizable social types. Its aim is to improve society morally.

SATURATION Refers to the purity or intensity of a color.

SATYR In Greek myth, half-man, half-goat, notorious for lust. They are frequent companions of the god **Dionysus.**

SCALE In art, the relative size of an object when compared to another like it or to a human being. In music, an arrangement of **notes** in ascending and descending order according to **pitch.**

SCANSION The analysis of a poem's **meter** using conventional symbols for marking long and short syllables and dividing **feet.** See **meter.**

SCENE A subdivision of a **drama;** also an episode in a **narrative,** whether literary or pictorial.

SCENERY The background environment and physical props in a **drama.**

SCEPTICISM, sceptic A view that questions our ability to gain reliable knowledge or discover truth. The broadest form of scepticism believes *no* truth about *anything* is possible. More limited forms may disbelieve in the possibility of discovering the truth about **ethics,** history, religion, or **consciousness,** and so on.

SCHERZO A **movement** in a **suite, sonata,** or **symphony.** Some composers have written scherzos as independent works.

SCHOLASTICISM, scholastic The tradition of learning that developed in **medieval** "schools" from the thirteenth to fifteenth

centuries, and that is associated with the **methods** and beliefs of Thomas Aquinas (1224/25–1274) and Duns Scotus (1266?–1308), which in turn were influenced by St. Augustine (354–430) and Aristotle (384–322 B.C.). Scholasticism's goal was to integrate and to reconcile **philosophy** and **theology,** or **reason** and faith, and it employed a logical and systematic form of argumentation. Sometimes a negative term suggesting an uncritical, rote adherence to a pre-formed, traditional philosophical system. See **Thomism.**

SCIENTIFIC METHOD Though currently there is much debate about scientific method (for example, whether there is one or many), generally this term refers to the systematic procedures for pursuing knowledge, including the formulation of the problem, the gathering of supporting data through observation and experiment, and the creation and testing of **hypotheses.** See **empiricism.**

SCIENTIFIC REVOLUTION The important shift in how people viewed the **natural** world and how they determined true knowledge, starting in the sixteenth century with the astronomy of Copernicus (1473–1543), Kepler (1571–1630), and Galileo (1564–1642). The movement expanded rapidly in the seventeenth century with the philosophy of Francis Bacon (see **Baconian**), and the mathematics and physics of Isaac Newton (see **Newtonian**). Rather than accept traditional authorities, whether religious or **classical,** for the truth about the world, now people would rely on their own experience (see **empiricism, inductive**), including experimentation, and they would offer solutions based on mathematics; only problems or questions that could be put in mathematical form were deemed suitable. The goal was to find universal laws of **nature** that could be mathematically demonstrated. See **New Science, scientific method.**

SCORE A written or printed record of the **notes** of a musical **composition.**

SECONDARY COLORS The **hues** resulting from the mixture of **primary colors.** For example, green is a secondary color resulting from the mixture of blue and yellow.

SECOND COMING See **Last Judgment.**

SEMIOTICS, semiology The science of **signs.** As a type of literary and art criticism, semiotics analyzes literary and artistic works as the productions of a system of rules, accepted practices, and traditional techniques that allows the work to communicate a message—the devices and features and their relations (to each other and to past examples of them) of **genre, meter, imagery,** types of **characters** or subjects, **conventions,** and so on, that determine, limit, and shape the choices the writer or artist makes and that account, more than does the artist's intentions, for the finished product and its meaning. In this view, the work of literature or art tends to be not about life or humans but about the system of literature itself and its function as a system. Thus, a **realist** novel is no more true than a **romance** but is simply the product of different **genre** systems and their expectations, accepted practices, and storytelling devices. Think of the use of **perspective** in a painting: The three-dimensional space is an illusion created by a technique with its own devices, rules, and history. In reality, the canvas is flat, and there is nothing behind it, just like a painting that does not use perspective. See **deconstruction, structuralism, sign, theory.**

SEMITES Peoples living in the Middle East such as the Jews and the Arabs, and ancient peoples such as the Assyrians and Phoenicians.

SENSIBILITY A term that became popular in the eighteenth century. Sensibility refers to a person's sensitivity and intense emotional reaction to other people's suffering, or one's own feelings aroused by suffering, beauty, and so on, including these as depicted in works of art and literature. Jane Austen satirized the excesses of this fashion in her novel *Sense and Sensibility* (1811).

SEQUENCE The repetition of a musical phrase at a higher or lower **pitch.**

SESTET A six-line section of a poem. See **sonnet.**

SETTING Where the events of a story happen, including physical location and time period.

SEVEN LIBERAL ARTS The curriculum of a **medieval** education divided between the *quadrivium,* arithmetic, astronomy, geometry, and music; and the *trivium,* grammar, **rhetoric,** and **logic.**

SEVEN YEARS WAR A struggle between Prussia and Britain on one side, and France, Austria, Russia, Sweden, and Spain on the other from 1756–1763. The main bones of contention were the rivalry between France and Britain in North America, and the fight for supremacy in Germany between Prussia and Austria.

SFUMATO Subtle gradations of light and dark and the blurring of lines used to **model** figures in a painting.

SHADING In painting, darkening parts of a body or object to create the effect of shadows.

SHARP A sign that indicates that a **note** should be raised by one half-step. More generally, used for a **tone** that is sung or played above its normal **pitch.**

SHORT STORY A brief fictional story, which can mean anything from 250 to 15,000 words. The boundaries between the short story, the short novel or novella, and the novel are rough. Short stories tend to differ from novels in their concentration on developing one aspect of fiction—**character, theme,** mood, and so on—whereas good novels engage all such aspects.

SIBYL In Greek and Roman myth, a female prophet who lived in a cave near Cumae in southern Italy. Eventually twelve sibyls

would be named and recognized by Christianity because they were believed to have foretold the coming of Christ.

SIDE AISLES In a **cathedral** or **basilica**, the aisles flanking the **nave**. See Figure 1.

SIGN, signifier, signified A term brought into literary criticism from the linguistic theories of Ferdinand Saussure, who defined language as a system of signs. A sign is made up of a signifier, either sounds or written marks, and a signified, a concept or mental notion or idea. The relationship between signifier and signified is arbitrary; that is, there is no necessary, logical, or natural connection between the sound "dog" and the written word, and the idea of a dog, because the same idea can have as a signifier *canis* or *perro* or *chien.* In addition, the signifiers take their identity from their position in the language system. Likewise, concepts are ideas whose meaning comes from the whole system and that arbitrarily divide reality along principles that differ from culture to culture. We may divide animals, for example, on the basis of whether they suckle their young or not (hence, the concept *mammal*), whereas the ancient Hebrews divided animals into clean and unclean, those that could be eaten and those that couldn't. It is a common error to think that Saussure said the sign's relationship to its referent—the piece of reality the sign refers to—is arbitrary, as though the referent rather than the concept were the signified. Once a culture has in place a language system, the sign's relationship to its referent is definitely *not* arbitrary. See **semiotics, structuralism, deconstruction.**

SIMILE A comparison made explicit by the words *like* or *as.* Like metaphors, similes make literature vivid and increase the sensory or emotional impact of words, render the unfamiliar or strange familiar, enrich ideas through added nuance or complexity, and make abstract ideas more immediate by comparison to the concrete. For example, when Homer in the *Odyssey* wants his audience to know what it sounded like when Odysseus and his men

ram the hot stake into the Cyclops's eye, he compares it to the more familiar and recognizable hiss that hot metal makes when a blacksmith dips it in water.

SOCIAL CONTRACT Developed in seventeenth-century political philosophy, the social contract is an imagined instrument created by people in a **state of nature** (that is, without government or any other kinds of associations or social structures), usually because their survival is threatened. These individuals gather together and consent to give up part of their autonomy and accept obligations to each other so that some form of communal authority can maintain order and security. Two famous works on the social contract are Thomas Hobbes's *Leviathan* (1651) and Jean-Jacques Rousseau's *The Social Contract* (1762).

SOCIAL CONSTRUCTIONISM The belief that knowledge and reality both depend on social relations and human practices that have a specific historical location and time. Thus, **objective** truth about the world, people, or society is not possible because historically determined ways of acquiring what passes for facts and evaluating among them can never be free from local prejudices, values, **ideology,** and so on.

SOCIAL DARWINISM A view of society popular in the late nineteenth and early twentieth centuries, in which human activity was interpreted in terms of competition and struggle for survival and power. In such a process, the weak and unfit would die out, and the strong would survive. See **Darwinism, naturalism.**

SOCIAL DEMOCRAT Someone who combines some aims of **socialism** with an acceptance of constitutional government and some features of **capitalism.**

SOCIAL HISTORY History that concentrates on social groups (particularly those previously ignored, such as ethnic minorities and women) and classes, investigating their problems, their

relations with one another, and the role they play in politics, economics, and **culture.**

SOCIALISM An economic and political view, explicitly formulated in the early nineteenth century, that believes **capitalism** is fatally flawed and unjust, and that (1) wealth needs to be in some way redistributed to correct economic injustice and the misery caused by industrialism; and (2) some level of collective ownership and rationalized control of capital, production, and property are necessary to avoid the evils of poverty, exploitation, and economic injustice. See **capitalism, communism.**

SOCRATIC, Socratic method Socratic refers to the ideas and methods of the Greek philosopher Socrates (470–399 B.C.). These ideas include the belief that the truth of **ethics** must be pursued through a **rational** procedure; that ultimate knowledge of the **good** for both humans and society is likely to be impossible (Socratic ignorance); and the importance of examination, the rational pursuit of knowledge of the good through the questioning of one's own and others' beliefs in order to expose false opinion that passes for true knowledge. The **Socratic method** is another term for the **dialectic,** the question-and-answer procedure through which someone's opinions are examined and shown to be incoherent or contradictory.

SOLILOQUY In a **drama,** a speech in which a **character** reveals his or her private thoughts to the audience but not to the other characters.

SOMME, Battle of Fought during **World War I** between the British and Germans from July to November 1916. At the cost of 600,000 men, the British drove back the Germans a few hundred yards.

SONATA A musical **composition** developed in the eighteenth century and consisting of four **movements:** The first is fast, the

second slow, the third a **minuet** or later a **scherzo,** and the last is fast again. Usually a sonata is written for one instrument or for two.

SONATA FORM A structure of a musical work containing three main sections: the exposition, the development, and the recapitulation. Sometimes an introduction precedes the exposition, and a coda follows the recapitulation. Often the first and fourth **movements** of a **symphony** have sonata form.

SOPHISTS A group of philosophers and teachers in ancient Greece that flourished mainly in the fifth through fourth centuries B.C. They traveled from city to city, giving public lectures and tutoring for a fee on many different subjects, particularly **rhetoric** and oratory. Though the various Sophist philosophers held a wide variety of beliefs, in the popular imagination they were considered **relativists** to some degree, who attacked traditional and religious beliefs using a clever and dishonest form of argument ("making the worse argument the better"). Protagoras (c. 490–420 B.C.), who said "Man is the measure of all things," is perhaps the most well-known Sophist.

SONNET A fourteen-line poem composed usually in **iambic pentameter** and following a wide variety of **rhyme patterns.** The sonnet is a very flexible form for developing a poem's **theme,** because the fourteen lines can be divided into various units. The Petrarchan pattern, after the fourteenth-century Italian poet Petrarch, has an eight-line unit (octave) that usually rhymes *abbaabba,* and a six-line unit (sestet), rhyming *cdecde* or *cdcdcd cdedce.* The Shakespearian sonnet has three four-line units (quatrain) and a couplet. The way the poem is divided into units and the rhyme patterns provide a wide variety of **structural** mechanisms that allow the poet to develop his or her idea with complexity and even drama, as, for example, in a Shakespearian sonnet in which the final couplet often contains a surprise or twist the reader perhaps did not anticipate. As with all poetic devices such as **meter** or rhyme, the form of a sonnet works best when

it is integrated into and reinforces the theme rather than being artificially and superficially imposed.

SOPRANO The highest woman's or child's singing voice. Also used for instruments that have a high range, such as the soprano saxophone.

SPANISH-AMERICAN WAR A conflict in 1898 between Spain and the United States over control of Spanish colonies such as Cuba, Puerto Rico, and the Philippines. Seen by some as an expression of U.S. **imperialist** ambitions, the war resulted in the independence of Cuba, the purchase of the Philippines from Spain, and the ceding of Guam and Puerto Rico to U.S. control.

SPANISH ARMADA A huge naval force (130 ships and about 27,000 men) sent by Catholic Spain to invade **Protestant** England in May 1588. Driven off by the English fleet, the armada was driven into the North Sea, with less than half of the ships making it back to Spain. The failure of the invasion gave **Elizabethan** England a surge of self-confidence and belief in its cultural and religious superiority.

SPANISH CIVIL WAR A war between the political **left** (Republicans) and **right** (Nationalists) in Spain from 1936–1939. The Nationalists were supported by **Nazi** Germany, whereas the Republicans were eventually abandoned by the Soviet Union. Many sympathizers of the Republicans from numerous countries volunteered to fight in Spain (the International Brigades). The war was characterized by the sort of brutality and atrocities that would become widespread during **World War II**, such as the bombing of civilian populations (immortalized in Pablo Picasso's painting *Guernica*). About 750,000 people died in battles, executions, and air raids.

SPARTAN Adjective used to invoke the **culture** of the ancient Greek **city-state** of Sparta, which was highly militaristic and politically oppressive.

SPHINX A creature with the head of a man or woman and the body of a lion. In Greek myth, such a creature terrorized the city of Thebes by asking everyone a riddle: What walks on four feet in the morning, two at noon, and three in the evening? Oedipus knew the answer—a human being.

SPONDEE, spondaic See **meter.**

SPOOF A humorous **parody.** See **parody.**

STALINIST Adjective used to evoke the kinds of brutal political oppression and terror associated with Soviet premier Joseph Stalin (1879–1953).

STANZA, stanzaic A division of a poem or song containing a certain number of **lines** usually arranged in specific pattern of **meter** and/or **rhyme.**

STATE The politically organized body of people occupying a territory, committed to the defense of its sovereignty, and possessing coercive powers over its citizens. See **nationalism.**

STATE OF NATURE See **social contract.**

STELE A vertical slab of stone used as a grave marker or other monument; often inscribed with writing, a poetic epitaph, or a **relief sculpture.**

STOICISM, stoic An ancient Greek philosophical school founded by Zeno of Citium (334–262 B.C.) and developed by Cleanthes (c. 330–c. 231 B.C.) and Chrysippus (c. 280–204 B.C.). Stoic philosophy believed that the world was an organic whole infused with divine **reason** (*logos*): The world was the "body" of god, and god was the "soul" of the world (see **providence**). As such, the world is rationally organized toward a good. Because humans possess a spark of the divine in our rational souls, we have a place in this order and an obligation to perform our duty in whatever role,

whether emperor or slave, the divine rational order of god has placed us. We must thus pursue **virtue**, which is the only **good** and which shares in the larger providential order and, hence, is natural for us.

STONE AGE The period of history before the use of metals to make tools and implements, which were fashioned from stones such as flint, quartz, or obsidian. See **Palaeolithic, Mesolithic, Neolithic.**

STRAW MAN A **fallacy** of argument that results when an opponent's position is oversimplified, misrepresented, distorted, or unfairly weakened in order to refute it more easily.

STRING QUARTET A group of stringed instruments that includes two violins, a cello, and a viola, and that plays **compositions** written for such a group.

STROPHE Originally the first structural unit in the choral songs in ancient Greek **tragedy,** later used for any unit in a poem, especially an **ode.**

STRUCTURALISM, structuralist A type of **literary criticism** deriving from the linguistic theories of Ferdinand Saussure and the anthropological writings of Claude Lévi-Strauss. Just as Saussure analyzed the language system that makes possible and gives meaning to individual instances of language use, Lévi-Strauss analyzed and described the underlying, formal, conceptual, and social systems that make possible a culture's particular practice or belief. Lévi-Strauss typically described these systems in terms of binary oppositions, ideas that are direct contrasts, such as "raw" and "cooked" or "male" and "female," and that must be related to each other in some way or other, sometimes by a mediating third term that reconciles them at some level. In literary criticism, structuralism focuses on literature as a system whose terms take their meaning and significance from their relationship to each other and to the system as a whole.

Generic elements, **imagery,** character types, figures of speech, storytelling techniques and rules are all determined not by the author's intentional meaning or by some relationship to reality but by the underlying system that provides a structural foundation for all these literary elements and their relations to each other both within the work and between the work and the whole literary system. Some structuralist criticism goes further and relates literary elements to other social or cultural systems (for example, political, economic, or religious) outside an individual literary work. See **sign, semiotics, poststructuralism, theory.**

STRUCTURE The form or framework of a work of literature, what gives it a particular shape, or the arrangements and organization of its parts. The elements of structure depend on the type of literature—the way the story is told, the sequence of events, can determine the structure of a **novel;** the acts and scenes the structure of a play; the imagery and ideas, **meter,** and **rhyme pattern** the structure of a poem. Good works of literature combine several structural patterns that can reinforce or be contrasted with and even challenge one another.

STURM UND DRANG German for "storm and stress," the title of a play in 1776. It became the general term for a late eighteenth-century literary movement that emphasized a violent and excessive expression of one's unique individuality and feelings in opposition to a dull, repressive society.

STYLE The peculiar use and arrangement of the elements of art and music—words in literature, color and **form** in art, sound and **rhythm** in music—that develop the idea or **theme.** Styles can also be associated with certain kinds of artistic or literary **genres** (**epic,** for example, has a certain kind of style obviously different from a **novel's**) or with historical periods; certain places; or with certain famous authors or periods in their lives. The choices an author makes from the all these elements of literature—language,

imagery, rhythm, figures of speech, **structure,** and so on—go into expressing his or her individual style.

SUBJECTIVE, subjectivism Describes the response to and estimation of reality and its truth that are conditioned by an individual person's feelings, perception, prejudices, and so on. See **objective.** Subjectivism describes judgments about people's tastes, perceptions, and opinions that cannot be established as factually true or false because they are based on individual experience.

SUBLIMATION, sublimate The diversion of an impulse (such as sex) from its original object to one more socially acceptable or less psychically disturbing. See **Freudianism.**

SUBLIME, the An **aesthetic** idea developed in the seventeenth and eighteenth centuries that postulated experiences or objects could be beautiful despite the lack of traditional elements or qualities associated with beauty. These objects arouse some feeling of awe, grandeur, mysterious power, terror, or exhiliration that cannot be rationally explained.

SUFFRAGETTES An English **feminist** political movement in the early twentieth century that campaigned, sometimes militantly, for women's right to vote.

SUITE A type of music developed in the **Baroque** period and popular in the seventeenth and eighteenth centuries, containing several **movements** in dance form. Later, a term used for a collection of short movements taken from **opera, ballet,** or soundtracks of movies. Sometimes a suite contains original material.

SUMERIANS A people living in the south of what is modern-day Iraq and Iran, near the Tigris and Euphrates Rivers, around 4000–3000 B.C. They developed complex political organization, irrigation technology to control the rivers, a legal system,

and a religious literature. They also invented a system of writing called cuneiform, which uses wedge-shaped symbols made by reeds pressed into wet clay.

SUN KING, the The French king Louis XIV (1638–1715) who established an absolutist **monarchy.** See **absolutism.**

SUPEREGO See **Freudianism.**

SUPERMAN, the See **Nietzschean.**

SURREALISM An artistic movement of the early twentieth century that attempted to gain true knowledge of the individual and to effect the individual's liberation from a **repressive** society by releasing his or her **unconscious** and irrational forces through hallucinatory, disjointed, dreamlike, incongruously juxtaposed, disturbing, shocking, and distorted **imagery** and **symbols.**

SYLLOGISM A type of reasoning containing a major premise, a minor premise, and a conclusion. For example, "All men are mortal; Socrates was a man; therefore, Socrates was mortal."

SYMBOL, symbolic, symbolize Something that stands for or calls to mind something else, especially something concrete and visible that represents an abstraction, such as the lion symbolizing courage or scales symbolizing justice. In literature symbols can be traditional, such as the color green symbolizing spring and youth, or water symbolizing rebirth, or the journey symbolizing human life from cradle to grave; or they can be peculiar to the author, such as Moby Dick, the great white whale in Herman Melville's *Moby Dick* (1851), which symbolizes a great many things during the course of the novel, and which perhaps is a powerfully evocative symbol precisely because what it symbolizes is never exactly defined but always suggested. Sometimes something can have one symbolic meaning in one context, and

another meaning in another context, and frequently writers develop private symbols. The color white, for example, frequently symbolizes purity or virginity; yet it can also symbolize sterility and death, as in Pynchon's *Gravity's Rainbow* (1973). The force of a symbol, then, will depend on its use in a particular context and for a particular artistic purpose as well as on its traditional meaning. And a good symbol will be one in which the similarities will go beyond superficial resemblances and evoke more subtle or complex associations—the tendency to interpret anything longer than it is wide as a phallic symbol, a representation of the penis, is an example of poor symbolization. See **image, metaphor.**

SYMBOLISTS Poetical movement of the late nineteenth and early twentieth centuries that rejected **realism** and favored instead the use of **symbols** to evoke individualistic impressions and emotions.

SYMPHONY A large work for an **orchestra** composed in the **sonata** form, although some symphonies have fewer than four **movements.** Also a term used for an orchestra that can play a symphony.

SYMPOSIUM In ancient Greece, a "drinking party" that frequently focussed on love and poetry. Sometimes used as a setting for a philosopohical **dialogue,** as in Plato's *Symposium* (c. 375 B.C.).

SYNCOPATION Shifting the stress to a **beat** that usually is not stressed.

SYNECHDOCHE, synechdochic A figure of speech in which a significant part of something stands for the whole thing. *Sail* is a common synechdoche for a ship, as is *hand* for a manual laborer. See **metonymy, symbol.**

TABULA RASA Latin for "blank slate." A phrase used to describe the mind in the view of some **empiricist** philosophers (especially John Locke [1632–1704]). In their view of knowledge, our minds are like blank sheets of paper on which experience "writes" information. See **empiricism.**

TAUTOLOGY The unnecessary repetition of a word or idea.

TECHNOLOGY, technological Most simply, technology refers to all the ways human beings systematically alter the **natural** environment in order to provide the means of survival. Thus, agriculture, cooking, and toolmaking are perhaps the most important technologies humans have invented. Other important ones are metallurgy (heating metals and alloys of metals so that they can be shaped into tools and weapons), architecture, and shipbuilding. The **scientific revolution** made possible ever more powerful and complex technologies such as railroads and steam-driven machinery, which fueled the **industrial revolution.** Since the midtwentieth century, technological advances and changes have exploded in every area of human endeavor—communications, electronics, travel, warfare, medicine, and especially computers.

TELEOLOGY, teleological The idea that things can be accounted for in terms of some goal, end, or ideal completion they help bring about. A teleological view of history, for example, would explain historical events in terms of some future goal or ideal state—the coming of Christ in Christianity, or the classless society in **Marxism.** See **providence, salvation history.**

TEMPERA A **pigment** mixed with a substance such as glue or egg.

TEMPO The speed at which music is played.

TENOR The highest adult male voice.

TERCET A three-line poetic **stanza.**

TERROR, Reign of During the **French Revolution** from 1793–1794, the revolutionary government began executing those perceived to be a threat to its power, eventually killing 12,000 people, including **political prisoners,** aristocrats, priests, and many revolutionary leaders who had themselves earlier condemned their enemies.

TERRORISM The systematic use of extreme violence to bring about political change, including kidnapping, murder, and bombing of civilians as well as of military personnel.

TETRAMETER See **meter.**

TEUTONS, Teutonic A Germanic tribe that migrated into what is now southern France and northern Italy around the second century B.C. They disappeared a couple of centuries later, but their name survives as a synonym for German.

TEXT A specific piece of written material. When not just used as a fancy word for a literary work, text usually implies a **post-structuralist** view of writing or other cultural productions, even those not using writing, as an **epiphenomenon** of various social or political forces.

TEXTURE In painting, what sort of feeling (rough, smooth, etc.) the surface suggests. In music, the number of **melodies** in a piece—the more melodies, the thicker the texture.

THEME, thematic What a work of literature is about, its **idea,** whether explicitly stated or implied by the work as a whole, and something that is said about the idea. Great works of literature

seldom have a single clear-cut theme nestling in the work like a nut in its shell. Rather, there may be suggested several themes or variations of a theme or attitudes toward and opinions about the theme, and all usually will not be definable except at a very general and uninteresting level, like saying Shakespeare's *Othello* (1604–1608) is about jealousy. You might as well say it is about life. The theme of a literary work will be more complex and nuanced, suggestive of several interpretations, sometimes even conflicting, rather than reducible to one. In music, the theme is a phrase or **melody** that makes up an **idea** that the music is trying to communicate. The theme is often repeated with variations.

THEODICY An explanation of why evil exists if God is just and all-powerful: a justification of God's ways to humans by looking at the larger purposes and goals of creation. See **providence.**

THEOLOGY, theological Literally, the "science of God." The systematic, coherent study of the nature of God and God's relationship to the world and human beings, as well as issues of religious faith, practice, and experience.

THEORY A theory is a general, abstract statement intended to explain phenomena in some systematic and coherent way. A good theory should also be able to have predictive power, that is, to explain how or why future phenomena occur.

Also, literary criticism that is concerned not with interpreting individual works (practice) but with the larger more general and speculative issue of defining what literary interpretation is and how it takes place, its procedures, mechanisms, devices, rules, and so on. *Theory* usually refers to **deconstruction** or **post-structuralism,** and the term carries **connotations** suggestive of their ideas. See **criticism, historicism, structuralism.**

THEORY OF FORMS See **form.**

THERMOPYLAE A narrow pass in northeast Greece where the allied Greek **city-states** stationed soldiers under the Spartan king Leonidas to guard against the invading Persians in 480 B.C. The Greeks were betrayed and outflanked, but the 300 Spartans and 700 Greeks from Thespiae remained at their post, ultimately dying to the man. The battle became famous as a representation of Spartan military valor and obedience to orders, as well as of the Greek passion for freedom over slavery. See **Greco-Persian Wars.**

THIRD REICH The **Nazi** regime in Germany from 1933–1945 under the dictatorship of Adolf Hitler (1889–1945); at one time it controlled all of Europe except Spain and England.

THIRD WORLD A term used to describe the countries of the world that are poor and as yet undeveloped industrially and technologically, including Africa (except South Africa), Asia (except Japan and some countries in Southeast Asia such as South Korea), and Latin America.

THIRTY-NINE ARTICLES The religious principles of the **Anglican Church** adopted in 1571.

THIRTY YEARS WAR Brutal battles and conflicts fought mainly in Germany between **Protestants** and Catholics from 1618–1648. The war was particularly destructive of lives and property.

THOMIST, Thomism Relating to or evocative of the philosophy and **theology** of St. Thomas Aquinas (1224/5–1274). More specifically, a philosophical school that developed from the main ideas of Thomas Aquinas on issues such as knowledge, **free will,** God's grace, **predestination,** and so on.

THOUGHT POLICE From George Orwell's novel *1984* (see **Orwellian**). Refers to a government agency in that novel that

monitors speech and writing and checks its **ideological** correctness, silencing those deemed to be subversive. Now used for any attempt to control ideas and speech or to enforce an intellectual orthodoxy.

TIMBRE In music, another word for **color** in reference to **tone.**

TIME The pattern of music's **rhythm** in terms of the number of **beats** per **measure.**

TINT Technically, a color created by mixing a **hue** with white in order to lighten it.

TITANS In Greek myth, the generation of gods that precedes the **Olympians** and that fought against **Zeus.** The most famous Titan was **Prometheus.**

TOCCATA A piece of music written for one instrument designed to demonstrate the performer's skill.

TONALITY Another word for **key,** or the quality of music that suggests a key.

TONE A sound with a specific **pitch.** In literature, tone refers to the mood, **atmosphere,** attitude, or some other intangible quality the work suggests.

TONIC In music, the main note of a specific musical **key.**

TOPOS A stock **theme** or topic.

TOTALITARIANISM, totalitarian A political system in which all of life both private and public is subject to the control of the **state.** Totalitarian governments are generally characterized by a single political party that controls all the institutions and offices of government; a single **ideology** communicated through **propaganda;** government control of the economy; and the use of **terrorism** against people by secret police.

TOTAL WAR Warfare directed not just against an enemy's army or supplies but against civilians as well—the destruction not just of the enemy's material but also of the enemy's psychological support.

TRAGEDY, tragic In literature, a dramatic **genre** created in ancient Greece that focuses on the failure or tragic flaw and the suffering of an important person. The fate of the tragic **hero** is significant usually because it represents a possibility for all of us, because we all are defined by the same passions and flaws, even those of us privileged by talent, wealth, or power. Tragedy also evokes and confirms a world of **nature** and the gods that frequently limits and destroys the aspirations that we humans have. Tragedy, then, is not just about suffering, which is how we usually use the word—it is suffering that carries a **philosophical** significance beyond the individual sufferer.

TRAGIC FLAW See **tragedy.**

TRANSCENDENTALISM Generally, transcendentalism refers to belief in the existence of things—for example, spirit, soul, God, or **Platonic ideals**—that go beyond the experience of the senses and the material world, are considered the fundamental reality and basis for all knowledge and are truly real. See **metaphysics, materialism, empiricism.**

A more historically specific form of transcendentalism, New England transcendentalism, is associated with the nineteenth-century U.S. writers Ralph Waldo Emerson (1803–1882) and Henry David Thoreau (1817–1862), among others. New England transcendentalism emphasized the spiritual unity of the world (see **pantheism**) and the power of intuition to acquire knowledge superior to that gained by mere sense experience. See **romanticism.**

TRANSEPT In a church, the "arm" that crosses the **nave** at right angles. See Figure 1.

TRANSUBSTANTIATION See **Eucharist.**

TREBLE The highest sound of an instrument or voice.

TRENCH WARFARE A form of warfare in which soldiers stay in long ditches from which they attack the enemy in mass. In **World War I** both sides built extensive networks of trenches, sometimes only yards apart from one another (the space between called "no man's land"). The introduction of rapid-firing weapons such as machine guns made the mass charges virtually suicidal, which accounts for some of the horrendous casualties in World War I.

TRIBUNE In ancient Rome, an official elected by the Roman nonaristocrats to protect their interests. Sometimes used for any official who champions (or pretends to champion) the interests of the common people against the dominant power.

TRILOGY Three separate works that form a continuous **thematic** whole. In ancient Greek **tragedy,** three plays performed at the same time and interrelated thematically. Only one trilogy has survived from ancient Greek tragedy, Aeschylus's *Oresteia* (458 B.C.).

TRIMETER See **meter.**

TRINITY, the In Christian **theology,** a name for God when viewed under the three aspects of Father, Son (Jesus Christ), and Holy Ghost.

TRIPTYCH See **altarpiece.**

TRIREME The warship of the ancient world, powered mainly by about two hundred rowers sitting three to a bench, angled so that each man could pull an oar. A ram of metal or wood was at the front and was used to shear off the oars or poke a hole in the enemy's ship.

TROCHEE, trochaic See **meter.**

TROJAN HORSE See **Trojan War.**

TROJAN WAR A mythic, ten-year war fought between the Greeks and Trojans, usually dated from 1184–1174 B.C. The war began when the Trojan **Paris** ran off with the Greek woman **Helen.** Helen's husband Menelaus and brother-in-law Agamemnon gathered an expedition of warriors to retrieve Helen and punish the Trojans. The war dragged on for ten years until **Achilles** slew **Hector.** Shortly thereafter the Greeks take the city with the Trojan horse, a huge wooden horse filled with chosen Greek warriors. The Greeks pretend to sail home and they leave the horse as an offering, which the Trojans drag into their city. Then the Greeks sneak out of the horse and let in the rest of their army, which proceeds to destroy the city.

TROMP L'OEIL French for "deceive the eye." A painting or effect in painting in which objects are so realistically depicted that they appear real.

TROPE Another term for figure of speech, the use of words or expressions not in their literal sense but to call to mind another meaning. See **metaphor** and **simile.**

TROUBADOUR A poet and singer in southern France during the eleventh century who wrote poetry about **courtly love** and **chivalry.**

TUDOR The family name of several English kings, especially Henry VIII (1491–1547) and Elizabeth I (1533–1603). Sometimes used as an adjective to describe English culture and history in the sixteenth century.

TYRANNY, tyrant In ancient Greece, a tyrant was typically an aristocrat who seized power, usually through force, and ruled with the support of the common people. Many tyrants accomplished

much that was good, breaking the power of the aristocratic clans and allowing for more political participation on the part of the nonaristocrats. However, because they came to power through violence outside the legal mechanisms for acquiring power, tyrants depended on secret police and political assassination to maintain their power. By the fifth-century B.C. (by which time most **city-states** had banished their tyrants) tyrants had become the emblems of the dangers of absolute power in the hands of fallible, passionate humans. Today tyranny refers to oppressive governmental power outside of law or a constitution.

UNCONSCIOUS A part of the mind believed to be a repository of various desires, wishes, impulses, **repressed** memories, sometimes creativity or wisdom, and to be inaccessible to **consciousness** yet somehow able to influence behavior. Sometimes called the subconscious. See **Freudianism.**

UNITED KINGDOM The country made up of England, Wales, Scotland, and Northern Ireland.

UNIVERSAL The concept to which general terms refer apart from the particular things in the world that the term describes.

UTILITARIANISM, utilitarian A philosophy that equates the **good** with pleasure, well-being, and the satisfaction of desire, and that judges the rightness of an action from the consequences of that action in furthering the most happiness and well-being for the greatest number of people. Particularly associated with the English philosopher Jeremy Bentham (1748–1832).

UTOPIA, utopian, utopianism From the title of a book by Sir Thomas More (1477–1535), *Utopia* (1516), from Greek words that could mean "no place" or "good place." An imagined idealized world better than the one we live in, and a kind of fiction that describes such worlds. Plato's *Republic* (fourth century B.C.) is the earliest example known. Utopian fiction over the years has been useful for developing philosophical and political **themes;** much contemporary science fiction is utopian. More science fiction is **dystopian,** that is, it describes an imagined world much *worse* than ours. George Orwell's *1984* (1949) is a classic example. Also used for political programs that imagine ideal worlds to be created if certain political **ideologies** are followed: **Communism** was (and is) a **utopian** political philosophy.

UT PICTURA POESIS A Latin phrase meaning "as is painting, so is poetry," from the ***Ars Poetica*** of the Roman poet Horace. In **aesthetic** theory of the sixteenth through eighteenth centuries this phrase summarized the view that both arts, but especially poetry, strive for the imitation of reality, especially human nature, particularly in terms of its transcendent or idealizing beauty.

VALUE What allows us to determine whether a color is light or dark, as in the distinction between light blue and dark blue. A lighter shade has high value and a darker shade has low value.

VALUE JUDGMENT The assessment of a past people, art, literature, and events from the standpoint of a particular set of **ethical** or **moral** beliefs. Something for historians and critics to be careful about, as it runs the risk of **presentism.**

VANDALS A Germanic people that in the fourth century A.D. were driven by the **Huns** into **Gaul** and Spain. They eventually sacked Rome (455) and established a kingdom in North Africa that lasted until the sixth century. Their destructiveness has made their name a term for senseless destruction.

VANISHING POINT See **perspective.** See Figure 4.

VASSAL See **feudalism.**

VAULT A ceiling made out of **arches.** See **barrel vault** and **groin vault.** See Figures 2 and 8.

VENUS Roman name for **Aphrodite.** Mother of **Aeneas.**

VERISIMILITUDE Literally "likeness to truth." When used for literature, it refers to how closely the writer approximates the truth or the appearance of truth, or how closely his or her work duplicates the appearance of reality or life. Thus, a work of science fiction can have verisimilitude if it suggests reality, even if it is a contrived one. See **realism.**

VERSAILLES A huge palace 10 miles from Paris, built by Louis XIV; it was the seat of French government starting in 1682. It came to symbolize the elaborate ceremony and servile flattery necessary for advancement in the ***ancien régime,*** as well as its wasteful luxury and corruption.

VERSAILLES PEACE TREATIES The series of agreements that ended **World War I** (1919–1923). The (to some) harsh and humiliating conditions and terms laid on Germany in the first treaty of June 1919 (the loss of important territories such as the Rhineland and the stiff economic reparations, for example) were resented in Germany and helped bring Hitler and the **Nazis** to power.

VERSE A line of poetry or poetry written in formal **meter** and **rhyme.** Sometimes the term implies poetry of a lesser quality or seriousness.

VERS LIBRE French for **free verse.**

VESPERS An evening service in the Catholic Church held at 6 P.M.

VIBRATO In music, an effect created by rapid variations in **pitch.**

VICHY The **autocratic,** collaborating French government after its defeat by the Germans in **World War II** in 1940. It collapsed with the defeat of Germany in 1945.

VICTORIAN An adjective describing the history, society, **culture,** art, and literature of England, the United States, and Western Europe during the reign of Queen Victoria (1819–1901, who became queen in 1837). Also used negatively to describe nineteenth-century middle-class society as one obsessed with propriety, **repressed** sexually, hypocritical, materialistic, moralistic, and stuffy.

VIETNAM WAR The war between **nationalist** and **communist** Vietnamese from the North, and Vietnamese in the South supported by the U.S. military (1964–1975). Despite intensive (but selective) bombing and the deployment of nearly half-a-million troops, the United States could not commit to a decisive strategy because of opposition to the war in the United States. A peace treaty in 1973 ended the war and the communist attempt to conquer the South, but when the treaty was violated by the North Vietnamese, the United States did nothing in response, and the South fell.

VIEWPOINT The spot from which a viewer looks at something. In a painting, there can be one or several viewpoints. See **point of view.**

VIKINGS Scandinavian pirates and traders active from the eighth to the twelfth centuries. The Vikings were excellent seamen and feared marauders and fighters, sailing their long-ships up rivers to

sack and plunder **monasteries** and towns. Their descendents, the **Normans,** settled in northern France. See **Normans.**

VILLANELLE A complex **metrical** pattern consisting of five **tercets** with a **rhyme pattern** of *aba,* followed by a **quatrain** with an *abaa* pattern. In addition, the first **line** of the first tercet is the last line of the second and fourth tercets; the third line of the first tercet is the last line of the third and fifth tercets; and these two lines (the first and third lines of the first tercet) are the last two lines of the poem. "Do Not Go Gentle into That Good Night," by Dylan Thomas (1914–1953) is a well-known villanelle in English.

VIRTUE A **moral** quality or excellence; also conformity to standards of proper moral behavior. In ancient **ethics,** there were four cardinal virtues—temperance (self-control), justice, courage, and wisdom. **Medieval** Christian ethics added three theological virtues: faith, hope, and charity.

VIRTUOSO A very technically skilled musical performer or singer.

VOLUME The quantity of space enclosed or occupied by a three-dimensional body.

VULGATE, the The Latin translation of the Bible by Jerome (c. A.D. 374–419/20).

WALTZ A dance in three-fourths time, which became popular in the early nineteenth century. The waltz at first was considered risqué because people embraced and danced as couples, whereas in most earlier public dancing people switched partners through-

out a dance. Many composers wrote waltz music, especially Johann Strauss (1804–1849) and his sons.

WAR CRIMES Actions during a war—killing and torturing prisoners or civilians, for example—that violate the accepted rules governing warfare, such as the **Geneva Conventions.**

WAR OF 1812 Fought between the United States and England, mainly around the U.S.-Canadian border. In 1814 the British burned Washington, D.C. The war ended that same year.

WARS OF THE ROSES A struggle lasting from 1455–1485 between two aristocratic English families: the Lancasters, whose emblem was a red rose, and the Yorks, whose emblem was a white rose. The wars ultimately ended when Henry Tudor defeated the Yorkist Richard III and married a York. The throne then passed to the **Tudors.**

WASH A thin coat of paint, used especially with **watercolors.**

WATERCOLOR A type of paint consisting of **pigment** mixed with water and a binding material (such as gum). Also, a picture painted with watercolors.

WATERLOO Fought June 18, 1815 between the French under Napoleon and the English and Prussians. Napoleon's defeat ended his military career, and he was sent into exile on the island of St. Helena.

WEST, the; Western A name for those societies (in Europe and the United States) defined by political, religious, and **cultural** principles deriving from the ancient Greeks and Hebrews, including **rationalism,** science, **monotheism, liberalism,** constitutional government, **democracy,** individual **rights,** the separation of church and state, and a high value placed on individual freedom.

WESTERN FRONT In **World War I,** the line of **trench warfare** stretching from Belgium to the mountains north of Switzerland.

WHEEL OF FORTUNE A wheel, usually decorated with representations of people from different social classes, professions, and so on, that **Fortuna** spins. When you are on top, you have happiness and material goods; but Fortuna always spins the wheel, and sooner or later you will lose those material goods, which will be given to somebody else. A favorite topic in **medieval** art, used to indicate that the true **good** for a human is connected to the soul and God, a good Fortuna cannot take away as she takes away the material goods.

WITCH HUNT A phrase that evokes the persecution of (mostly) women thought to be witches, peaking in the seventeenth century. Now used to describe any hunting down and persecution of those whose political ideas are unpopular or unorthodox.

WOMEN'S LIBERATION See **feminism.**

WOODCUT A **print** made from a design carved in relief on a block of wood; the raised design is then inked and applied to paper.

WORLD WAR I A destructive war fought between the Allied powers (England, France, Russia, Japan, and Serbia; later joined by the United States, Italy, Portugal, Romania, and Greece) and the Central Powers (Germany, Austro-Hungarian Empire, Ottoman Turkey, and Bulgaria), from 1914–1918. The Allied powers won, imposing conditions on Germany (see **Versailles Peace Treaties**) that contributed to the rise of **Nazism.** The war had a profoundly disturbing impact on the European imagination because of the new technologies of war introduced during the conflict, including aerial bombardment of civilians, tanks, machine guns, and poison gas; the seemingly pointless strategies and aims of those conducting the war; the huge number of casualties, including 10 million dead; and the horrors of **trench warfare.**

WORLD WAR II Fought between the Allies (England, the Soviet Union, and the United States) and the Axis Powers (Germany,

Italy, and Japan) from 1939–1945. The conflict was waged literally over the whole world, from Europe and North Africa to the Pacific. The horrors of **World War I** were intensified exponentially, with massive bombing of cities and civilians, more efficient and deadly military technologies, huge casualty numbers, and the **Nazi** murder of millions of Jews in **concentration camps.** Conservative estimates of people killed are around 50 million including 35 million civilians. Europe and Japan were devastated, the United States emerged as a dominant military and economic power, and the Soviet Union took control over Eastern Europe, initiating the **Cold War** with the United States and its allies. The Allied victory did, however, put an end to **fascism** as a political program.

Y

YAHWEH The Hebrew name for God. See **Judaism.**

YEOMAN A farmer who owns and works his own land and who possesses certain political and legal rights.

Z

ZEITGEIST The "spirit of the age." The idea that a historical period possesses a peculiar identity and set of values and assumptions underlying the whole of a society or **culture** and determining its intellectual, moral, and artistic behavior and productions.

ZEPHYR The West Wind in Greek myth, associated with spring and the coming of flowers.

ZEUS The king of the **Olympian** Greek gods, who enforces moral laws and is sometimes associated with cosmic order and justice.

ZIGGURAT A stepped pyramid built in ancient **Mesopotamia** and used as a temple.

ZIONISM A movement founded in 1897 that advocates and facilitates the return of the Jews to Palestine, considered to be the ancient homeland of the Jews.

ZOROASTRIANISM An ancient Persian religion that believed a permanent cosmic struggle went on between the forces of good and light (the god Ahura Mazda) and the forces of evil and darkness. Its founder was Zarathustra or Zoroaster (seventh to sixth centuries B.C.).

Credits

Figures 1, 2, 4, 7, 8 From James Smith Pierce, *From Abacus to Zeus, A Handbook of Art History,* rev. 5th ed. (Upper Saddle River, NJ: Prentice-Hall, Inc., 1998).

Figures 9, 10, 11 From Philip E. Bishop, *Adventures in the Human Spirit,* 2nd ed. (Upper Saddle River, NJ: Prentice-Hall, Inc., 1999).

Figures 3, 5, 6 From Janetta Rebold Benton and Robert DiYanni, combined edition, *Arts and Culture, An Introduction to the Humanities,* (Upper Saddle River, NJ: Prentice-Hall, Inc., 1999).

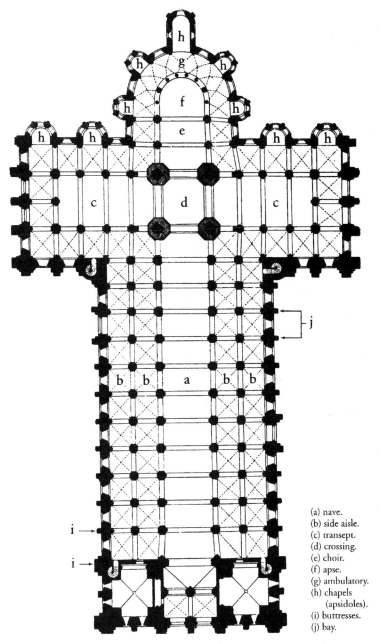

(a) nave.
(b) side aisle.
(c) transept.
(d) crossing.
(e) choir.
(f) apse.
(g) ambulatory.
(h) chapels
 (apsidoles).
(i) buttresses.
(j) bay.

Figure 1. Plan of a cathedral (St.-Sernin, Toulouse)

153

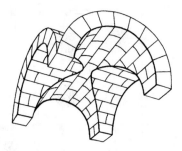

Groin vault seen from below.

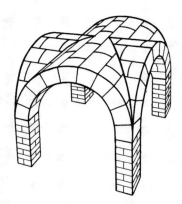

Groin vault seen from above.

Figure 2. Groin vaults

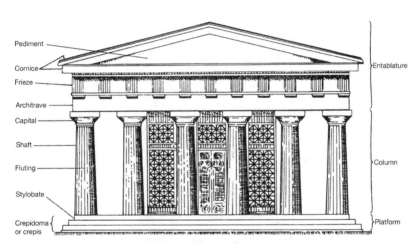

Figure 3. Elements of a Greek temple

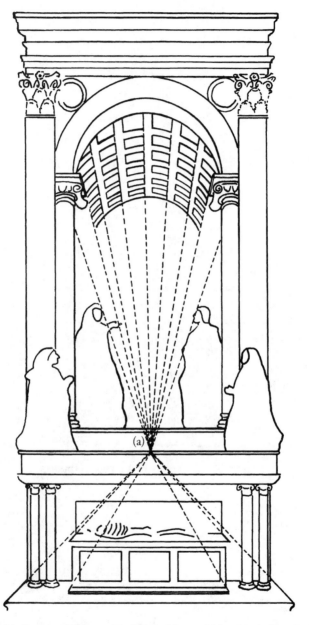

Perspective diagram of Masaccio's "Trinity" fresco in Sta. Maria Novella, Florence

Figure 4. Perspective.
a) Vanishing point

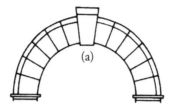

Round Romanesque arch

Figure 5. Arch. a) Keystone

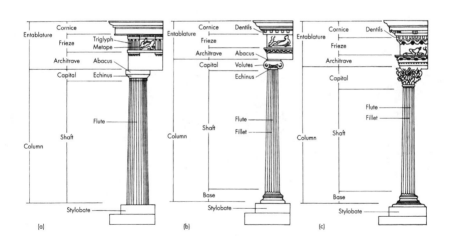

Figure 6. Orders of columns.
a) Doric b) Ionic c) Corinthian

a

b

Rod: (a) unforeshortened, (b) foreshortened.

Figure 7. Foreshortening

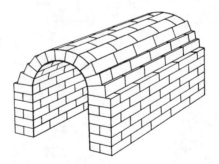

Figure 8. Barrel vault

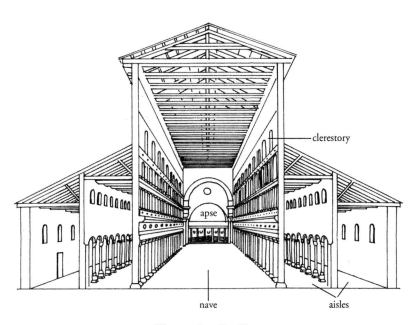

Figure 9. Basilica

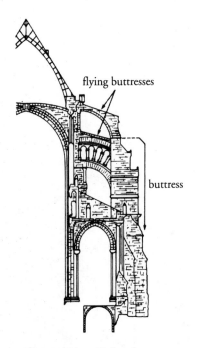

Figure 10. Flying buttress

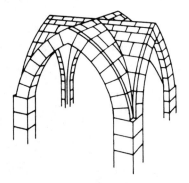

Figure 11. Cross-ribbed vaulting